With our love, For your 60th Birthday!
Daddo and Mama

Roshara Journal

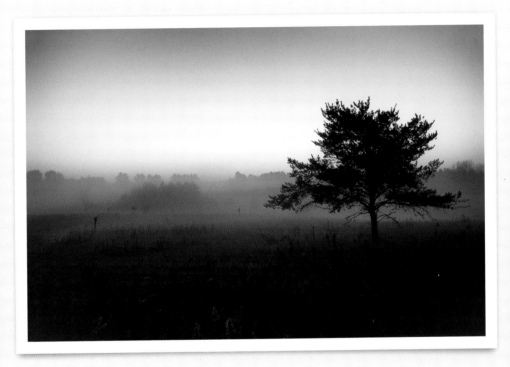

CHRONICLING FOUR SEASONS, FIFTY YEARS, AND 120 ACRES

Jerry Apps ▪ Photographs by Steve Apps

WISCONSIN HISTORICAL SOCIETY PRESS

Published by the Wisconsin Historical Society Press
Publishers since 1855

The Wisconsin Historical Society helps people connect to the past by collecting, preserving, and sharing stories.
Founded in 1846, the Society is one of the nation's finest historical institutions.

wisconsin**history**.org

Order books by phone toll free: (888) 999-1669
Order books online: shop.wisconsinhistory.org
Join the Wisconsin Historical Society: wisconsinhistory.org/membership

Printed in the United States of America
Designed by Percolator Graphic Design

20 19 18 17 16 1 2 3 4 5

Library of Congress Cataloging-in-Publication Data

Names: Apps, Jerold W., 1934– | Apps, Steve.
Title: Roshara journal : chronicling four seasons, fifty years, and 120 acres / Jerry Apps ; photographs by Steve Apps.
Description: Madison : Wisconsin Historical Society Press, [2016]
Identifiers: LCCN 2015042398| ISBN 9780870207631 (hardcover : alk. paper) | ISBN 9780870207648 (e-book)
Subjects: LCSH: Farm life—Wisconsin—Waushara County. | Farms—Wisconsin—Waushara County. | Country life—Wisconsin—Waushara County.
Classification: LCC S521.5.W6 A665 2016 | DDC 636.009775/57—dc23 LC record available at http://lccn.loc.gov/2015042398

Contents

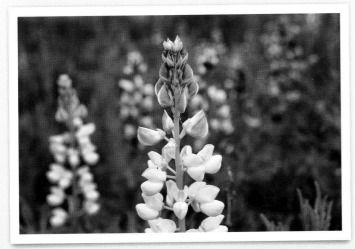

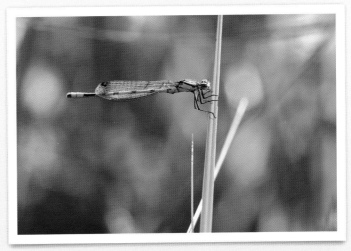

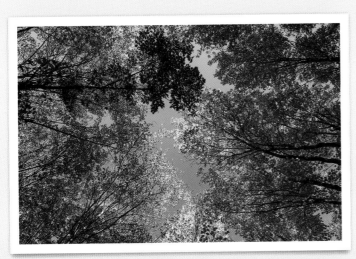

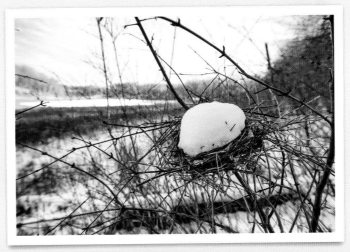

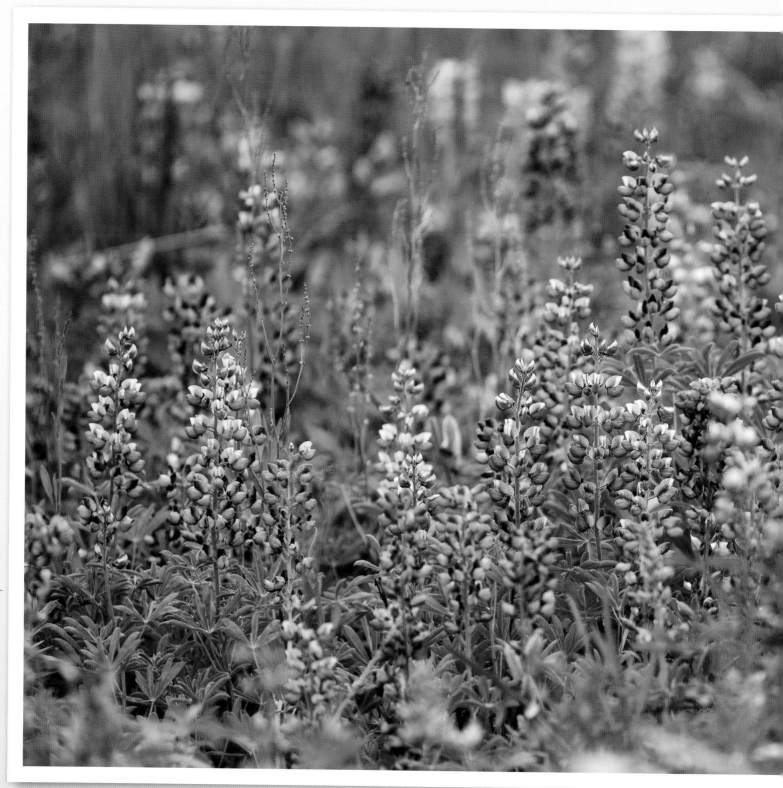

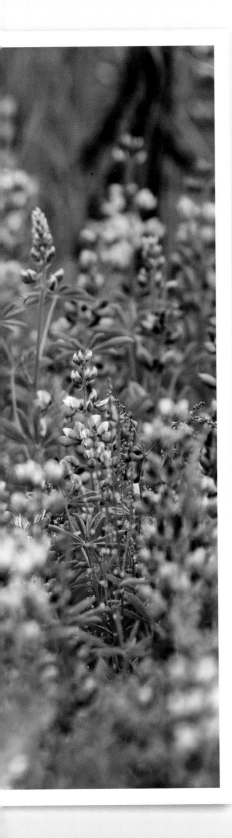

Introduction

I've kept a journal since I was twelve years old, so when Ruth and I bought a farm in central Wisconsin in 1966, I naturally began jotting down our experiences on this worn-out, hilly, stony and sandy land ("not much of a farm," one neighbor called it). Our children were two, three, and four at the time, so this has been a shared family adventure from the beginning, one that continues to this day.

We named our farm Roshara—combining the township name where the farm is located (Rose) with the county name (Waushara). As we've spent nearly fifty years here restoring the land to something like it was when it was first settled in 1867, we have seen many changes, and, I hope, several improvements. We are in the process of restoring a six-acre farm field to prairie—with a strategy that mainly consists of standing back and letting nature take its course. Each year we welcome the wildflowers and grasses, whose histories go back to presettlement days. We help them along by removing rogue trees and brush and mowing the prairie so the native plants have access to light and soil nutrients. But we've done no planting of wildflowers or grasses. This approach to restoration does not provide quick results, nor do I expect them. One of the many things I have learned from my connections to nature is patience.

A year after buying Roshara, I found a small patch of lupines growing on a hillside on the south side of the farm. With the clearing away of brush and nonnative trees, the lupine patch has grown to cover about three acres. As the fragrant, showy lupines have flourished, so have the endangered Karner blue butterflies that depend on them for their existence.

We have encouraged a self-seeded white pine plantation that grows on five acres of former cornfield. In the 1930s, a previous owner of this land planted a row of white pine along the western border of the field to stop wind erosion; it is those trees, some of them giants now, that provided the seeds for the new plantation. Our self-seeded pines, thinned once ten years ago, now stand more than forty feet tall, a reminder of the white pines that were native to central and northern Wisconsin. It's been amazing to see the transformation from cornfield to pine plantation happen without any help from anyone.

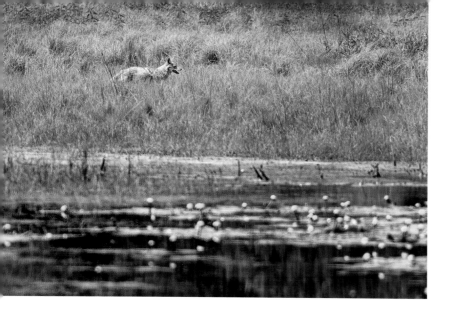

We've also planted several thousand trees here, mostly red pine, hand-planting one thousand trees every year during our early years of ownership and machine-planting about seven thousand in 2010. We've tried valiantly to prevent the spread of some undesirables, such as black locust trees, which spread like wildfire and grow like the worst weeds on the farm. With the help of a consulting forester, we are slowly winning the black locust battle. But the fight with buckthorn continues—another invasive that spreads rapidly in our shady oak woods.

We maintain a large vegetable garden that now provides three families with fresh-picked lettuce, tomatoes, potatoes, green beans, broccoli, and much more. It is in the garden perhaps more than any place on this old farm that I have taught my children and grandchildren about nature, about where the food they eat comes from, and about working together. As a family we have planted, weeded, and harvested together, and we've enjoyed many meals together featuring vegetables that we have grown.

Our 120 acres includes one pond, which we call Pond One, and half of a second pond, Pond Two. Wetlands embrace each of these three-acre seepage ponds, providing habitat for an abundance of wildlife and plants. Canada geese, sandhill cranes, and several duck species nest at the pond, accompanied by hundreds of frogs, turtles, and other aquatic creatures. We also see raccoons and occasionally a coyote, a fox, or even a bear sneaking around one of the ponds.

The ponds change with the seasons—higher in spring, lower in midsummer, and somewhat higher again with the fall rains. They have also changed dramatically over the years. When we bought the farm in 1966, the ponds were low. By the early 1980s they were the highest I have seen them, running over their banks and creating sizeable lakes. The water levels began falling in the late 1990s and have never come close to what they reached in the 1980s. Snow and rainfall amounts surely make a difference in the pond levels, but I am also confident that the amount of farm irrigation occurring in our township has an effect, as irrigation pumps draw millions of gallons of water from the aquifer that underlies our land. When the water table is high, our ponds are filled. When the water table drops, so do our pond levels.

For the first several years after we bought Roshara, we spent only summer vacation time here. In those years we slept in a tent, hauled in our water, cooked with a camp stove, and had but one "convenience"—a wooden outhouse I purchased from the Wild Rose Lumber Company. The farmhouse had burned down before we bought the place, and we worked hard for three summers to make the old granary, built in 1912, suitable as a cabin. We brought in electricity, fixed the well and pump, heated the cabin with a woodstove, and were able to spend three seasons here for several years. In 1988 we hired a carpenter to build an addition to the cabin and a well-driller to drill a new well. Now we had indoor plumbing and electric heat as a backup to our two woodstoves, and we could keep the cabin open in the winter. These days the family and I spend time at Roshara in all seasons of the year, writing, gardening, hiking in the woods, and sitting on the shores of the ponds.

Perhaps the most significant happening at Roshara over these many years is not what we have contributed to the place, but what it has done for my family and me. Our three children have grown up roaming Roshara's acres on their own, climbing trees, digging in the soil, helping plant trees, fishing in the pond, catching frogs, watching bluebirds, hiking the trails, identifying wildflowers, working in the garden, and much more. Roshara has added to their understanding of and appreciation for nature

in ways that I will never know. And now our grandchildren are doing the same. Three generations at Roshara, learning the importance of nature and coming to understand how we, in our small way, can make a contribution by caring for this land that was once declared worthless by the neighbors.

I continue to marvel at how the seasons come and go, how they seem the same year after year and yet profoundly different. One winter we may have four feet of snow on the ground, the next only four inches. One summer it rains nearly every week, and another it rains little and our garden suffers. Of the four seasons at Roshara, I enjoy autumn most of all. Despite what the official dates on the calendar might say, fall usually starts here in early September, with cooler days and the first leaves turning, and continues to late November, with the harsh sound of the wind moving through the naked tree branches.

My observations of the changing seasons are one of the many things I write about in my journal. I've used different kinds of notebooks over the years; today I write in artist sketch books, which I like for the high-quality paper. I write in longhand with a pen—never a pencil, which fades over the years. I write about nature but also about my family, my work, people I meet and books I've read, places I visit and what they have meant to me. And sometimes I just write about whatever comes to mind, without any purpose at all. Sometimes I write to figure out what I know—or don't know.

When I am at Roshara, I usually carry a notebook with me so I can jot down things I see, write about a feeling I have, or dig deeper into what these experiences at Roshara mean to me. These days, I find I frequently return to my earlier journals to see what I was observing, what I was thinking about, and what the family was doing in earlier days.

My journals are much more than mere jottings about nature. It seems that when I write about something—a bur oak tree, for example—that old tree becomes a part of me. The process of writing is a connecting experience, a way to interact with nature in a way that goes deeper than watching and listening. Writing takes me to a place that goes beyond observation and understanding, a place filled with feeling and meaning.

My son Steve, who joins me in this project, has been a professional photographer for more than thirty years. His memories of this land go back to when he was a child freely roaming the place and seeing it all from a child's perspective. When he was ten years old, he began snapping photos of what he saw. Today, with his photographer's eye, he sees a part of Roshara often missed by others.

In this book we share the passing of the seasons on this land, seen through Steve's photos and my journal entries, some of the latter going back almost fifty years. *Roshara Journal* is a reminder of how, despite the pace and challenges of modern life, the seasons continue to influence our lives in ways large and small. ∎

Oct 8, 1979

Yesterday was a fantastic fall day. Steve, two of his friends, and I went up to the farm on Saturday night. Yesterday morning the ground and the roofs were covered with white frost.

The boys were hunting. I spent the day cutting and splitting wood, and harvesting Indian and pop corn. I also loaded into the car all of the squash and pumpkins we grew this year. It was not a good squash year compared to other years. I would guess there was too much rain during the fruit setting time.

Next Saturday morning Jeff and I will sell at the farmer's market, then go up to the farm in the afternoon for another load of Indian and pop corn.

I constantly marvel at how quiet it is at the farm. Here

Spring

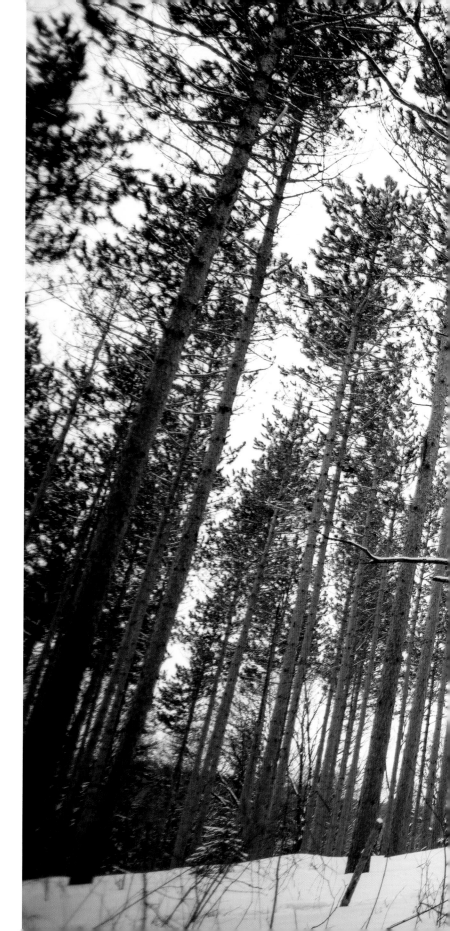

March 2, 1968

With the kids in tow, Ruth and I walked around the farm today. A few patches of bare ground show through the retreating snow on the south-facing hillsides. Green moss on these bare patches is a striking contrast to the worn and tired but still mostly white snow. The pond level is about eighteen inches lower than last fall—evidence of a snow shortage this winter. We stopped to rest in the white pine windbreak and five-year-old Steve asked, "What's that sound, Dad?" It was the sound of the wind blowing through the pine branches. I told him it was the trees talking to us. We both listened, each hearing our own message.

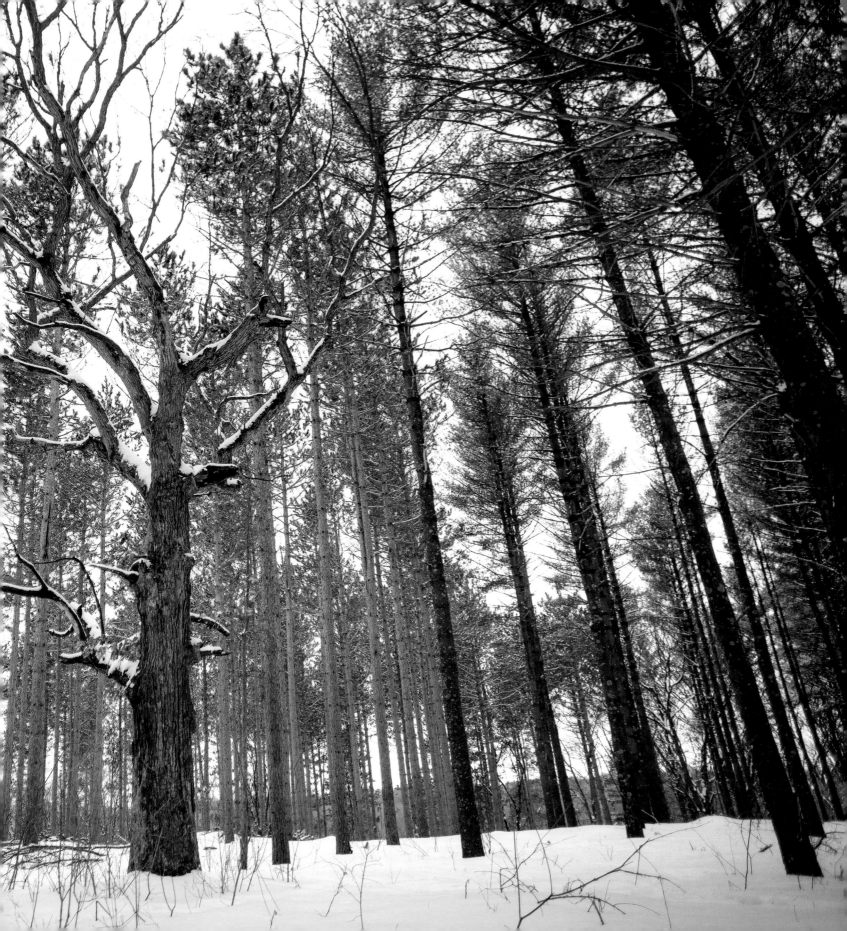

March 27, 2014

Roshara's fields remain snow covered. Two feet or more in most places. A few bare spots show through where the sun has managed to melt a little of winter. A cold, steady rain is working on the snow piles around the cabin, creating a meltwater pond between the cabin and the implement shed.

I heard sandhill cranes call this afternoon, returning from their winter home. The sandhills search for their summer nesting place on the west shore of Pond One, which is frozen and buried in snow.

According to the calendar, this is the seventh day of spring. Nature is once more reminding us that there is another calendar that is not written on paper and that varies considerably from year to year.

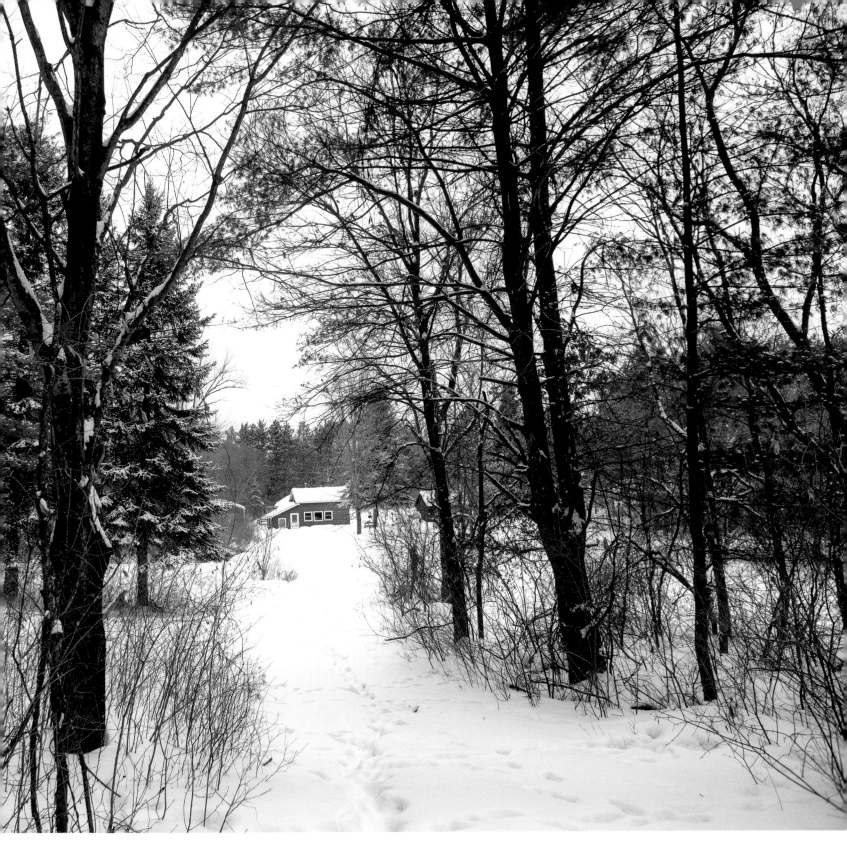

March 28, 1968

With the children's help, I made six bluebird houses out of large coffee cans to which I fastened wooden bottoms and tops. I cut a ¾-inch hole in the side of each can so a bird could enter. I also found a hollow block of wood with a hole in it, saved from burning in the woodstove. I nailed a roof and bottom to the block—another bluebird house? I asked Steve what kind of bird would like this rustic birdhouse. "I think you'll get a crow, Dad," he said.

Grandpa Apps and the kids helped me put up birdhouses. Each of the kids selected one of them, and we started looking for likely places to hang these rather crude nesting houses. Steve selected a birch tree on the top of the hill above the pond. He was sure a bluebird would like this location. Jeff chose a wild cherry tree standing by itself alongside the trail to the pond. Sue wanted her house near the pond, so we hung it on the branch of a willow tree on the east side and not far from the water's edge.

The kids then discussed where we should hang Mom's birdhouse, as she was not along with us. They finally decided that her birdhouse should hang on a small aspen tree on the west end of the pond. The discussion turned to one of the remaining birdhouses, which the kids said was Grandpa's. Grandpa chose an old wild apple tree near the west end of Roshara. And finally, my birdhouse, where should it go? It hangs in a lone aspen tree, near the edge of the farm. Now we are all looking forward to spring—and the return of the bluebirds—to see which houses might be occupied.

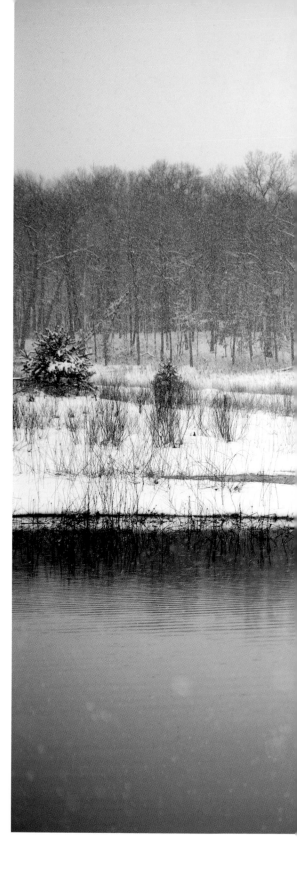

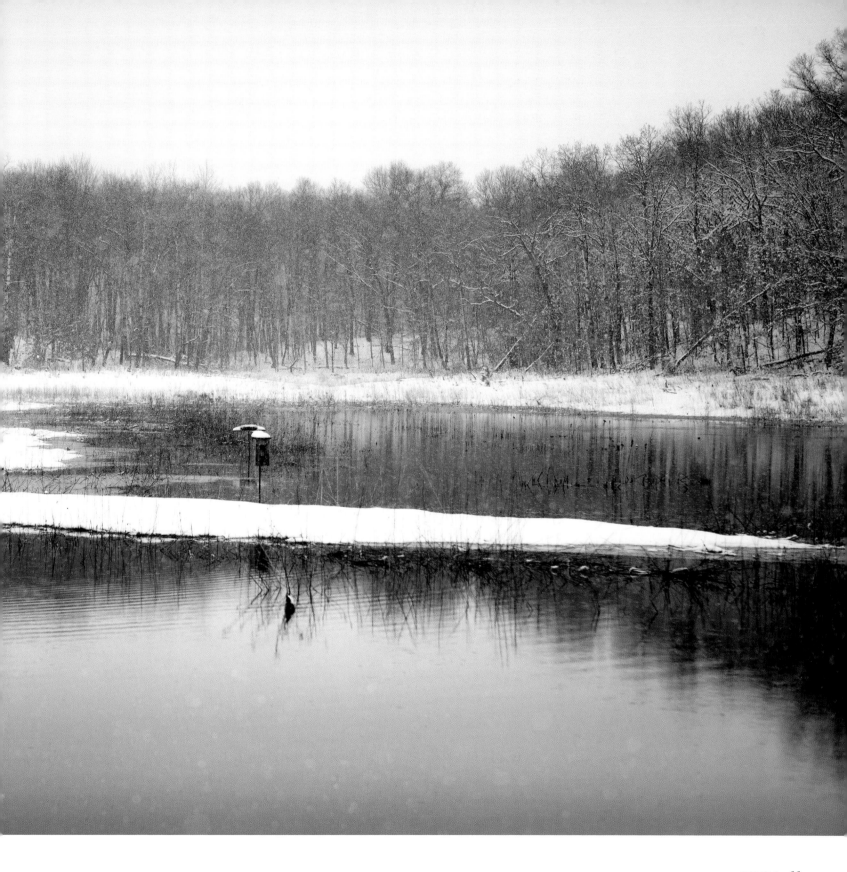

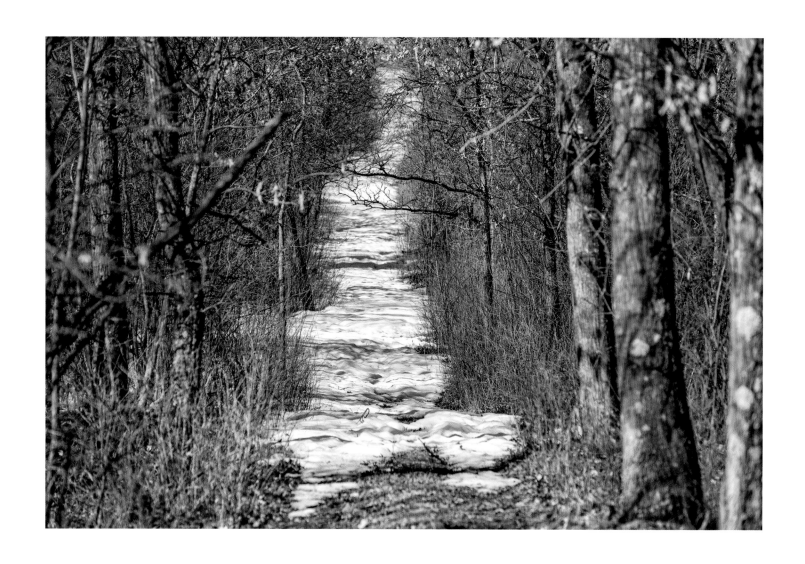

April 12, 1971

Beautiful day. Temperature in the high seventies, and yet some snow piles remain on the north sides of the hills. The boys had a snowball fight in their shirtsleeves. The pond is ice free, but it appears many of the pond's creatures died from the long, hard winter. I counted forty dead frogs in one place.

July 10, 2016

Dear Gayle:

Jerry Apps is a retired UW-Madison professor from the Ag Education department. Since retirement, he has written almost 30 books concerning various aspects of Wisconsin Rural Life. (Look up "Gerald Apps books" on Google). Quite a few years ago, when he was a graduate student I had him in a course in Social Research Methods. Recently we met, and he told me that I taught him how to do the research needed in his writing.

Hope you enjoy this text, much I think taken from his personal journal he began in the 1950s. And, the pictures are beautiful, done by his son, a professional photographer. His farm is near Wild Rose in the east-central part of the state.

Happy 60th year!

Daddo and Mama

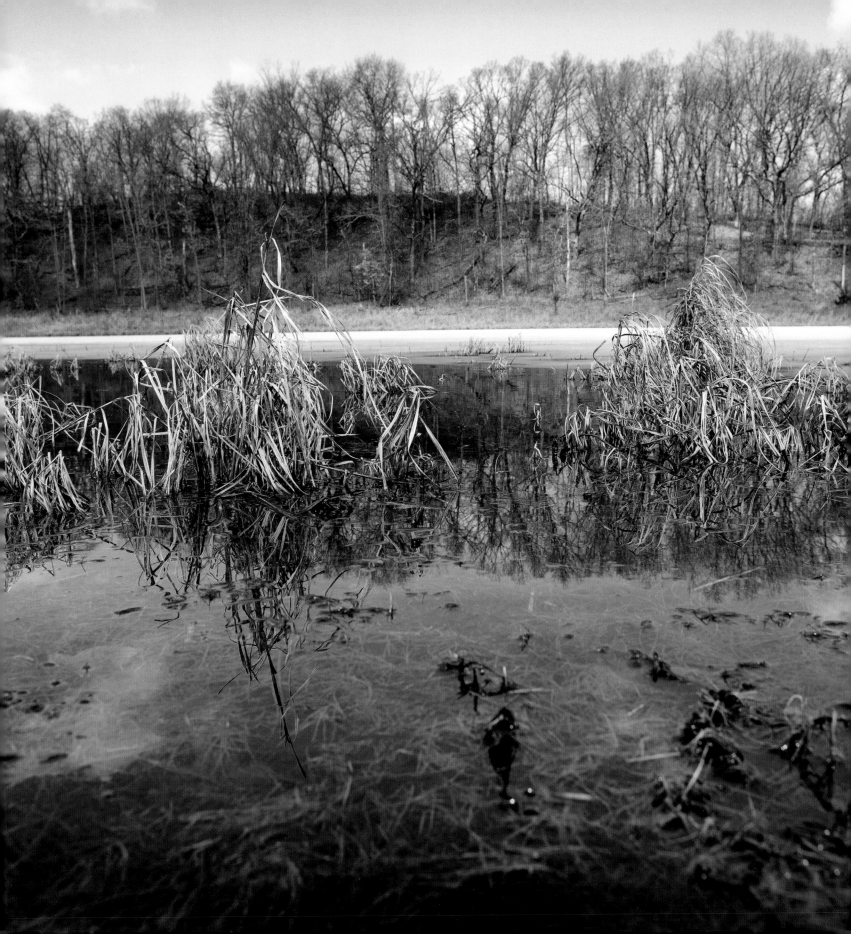

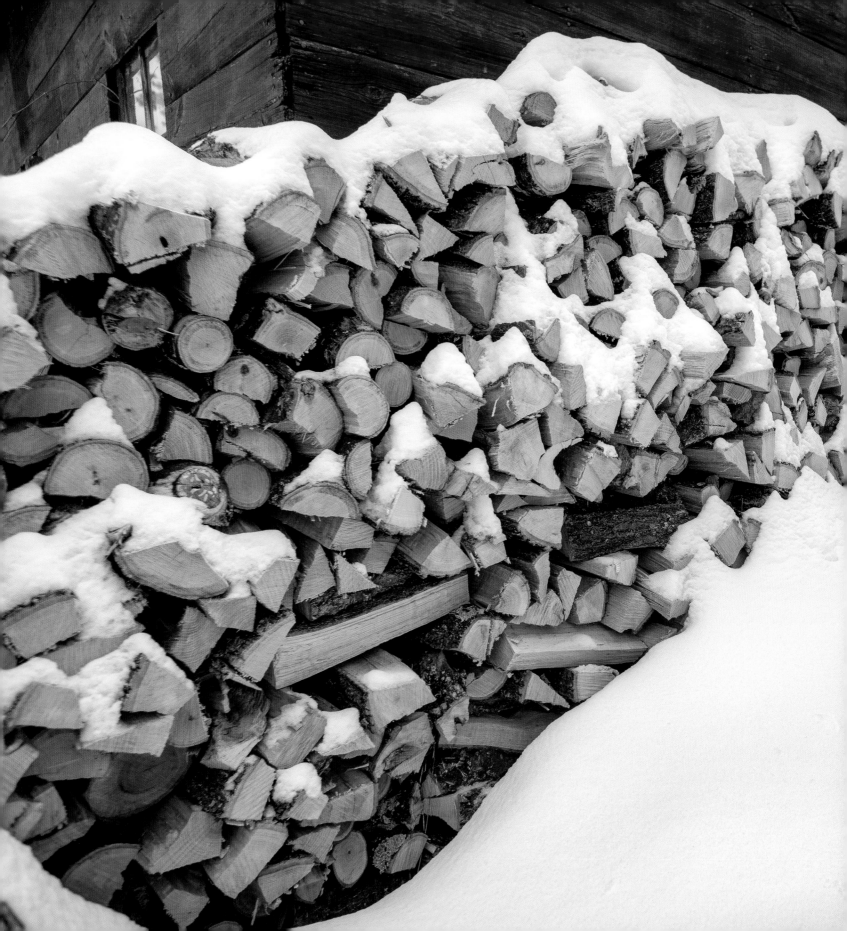

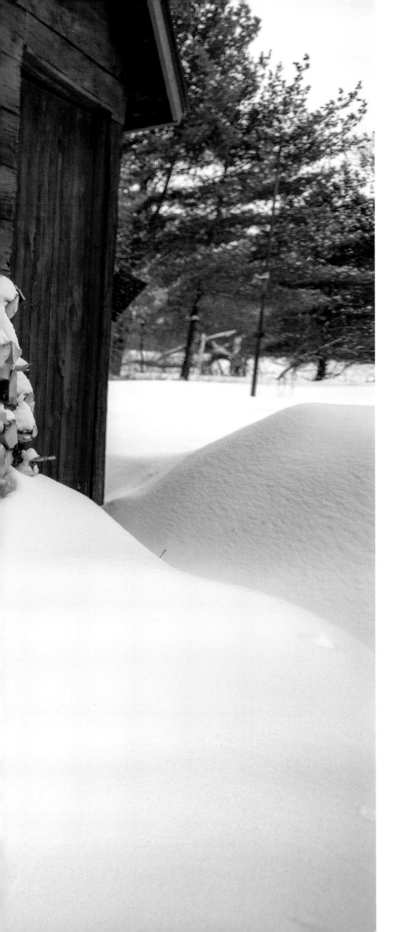

April 13, 2014

Rain pounds against the cabin window—hard rain. All afternoon and into the evening. Unrelenting. Steady. Much needed to awaken the spring flowers and add to the pond water. I go to sleep to the sound of the rain on the bedroom window—a pleasant, sleep-inducing sound. Hope for dry weather tomorrow, as it will be a workday with brush trimming and trail clearing.

April 14, 2014

The rain didn't stop. It turned to snow. Wet, heavy snow. An early March snow falling in mid-April. An April fool's joke two weeks late. I awaken to a beautiful world of white with snow clinging to everything—the bare tree branches, the cabin roof, my woodpile, the lawn that was bare yesterday. Everything covered with snow.

Nature's artistry, but not appreciated when spring is wanting, when winter should be a memory. The wind blows from the northwest, a gentle wind but a cold one. A wind of winter, not of spring. Patience, patience, I say. Spring is coming. But when?

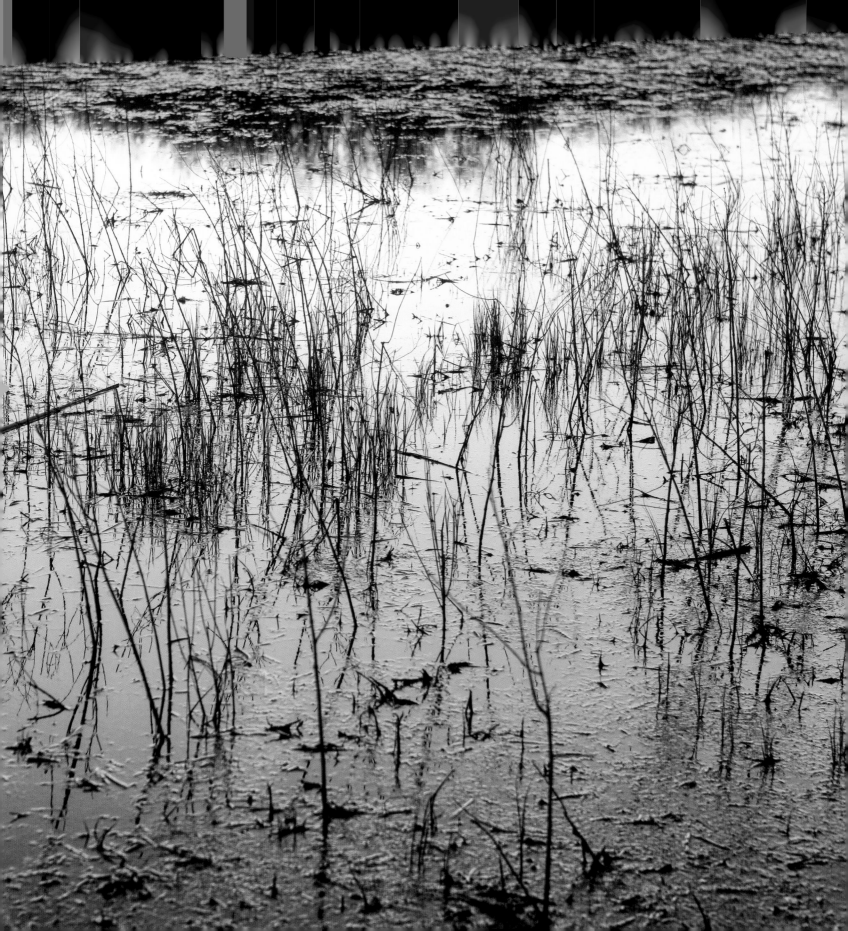

April 15, 2014

8 degrees and very wintry this mid-April morning. Much of yesterday's snow remains. Not at all a spring morning, more like January or February.

I walked to the pond yesterday afternoon through the mushy snow. The ice is gone, and the valley is an artist's picture in black and white. The brilliant white snow surrounds acres of cold, black water. Although Roshara's fields and forests are quiet and snow covered, the pond is alive with activity. The ducks have returned; I counted twenty of them, mallards and wood ducks and others I couldn't identify. They lifted from the pond's surface when they saw me, circling once and then winging their way north, to return when I leave, I'm sure.

I spotted a sandhill crane standing in shallow water on the east end of the pond. When it saw me, it, too, flew up, protesting my presence with its loud, prehistoric call. Once around the pond it flew, so low that I could hear the swishing of its enormous wings as it passed overhead. It flew to the north end of the pond and landed near a place where a pair of sandhills have nested for the past ten years, maybe longer. I wonder, are these members of the same sandhill family returning each year to the same place? I believe so. The mystery to me is how these big birds can fly hundreds of miles to winter in warmer places and return to exactly the same place each year. The pair usually hatches two little ones, and now I am wondering where the little ones go when they return north. Am I seeing the offspring, and the parents chose another location? Or do the offspring look elsewhere to nest? Unsolved mysteries.

Hugging the east shore of the pond I spot a lone Canada goose eying me. Walking along the shore, I spot a nest that is completely hidden until the female goose flies up and joins its mate on the pond. She had been sitting on the nest, which is on a tiny island a few feet from shore. As yet there are no eggs in the nest. I quickly leave, not wanting to disturb any further this new Canada goose family in the making.

With snow everywhere, it doesn't look or feel like spring. But the pond creatures know spring is here.

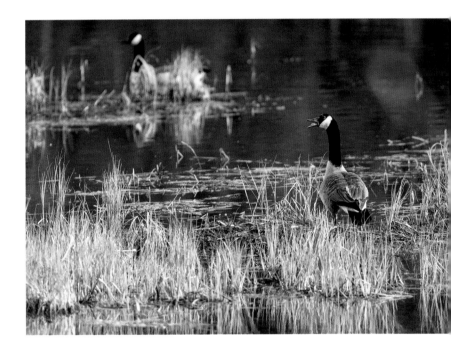

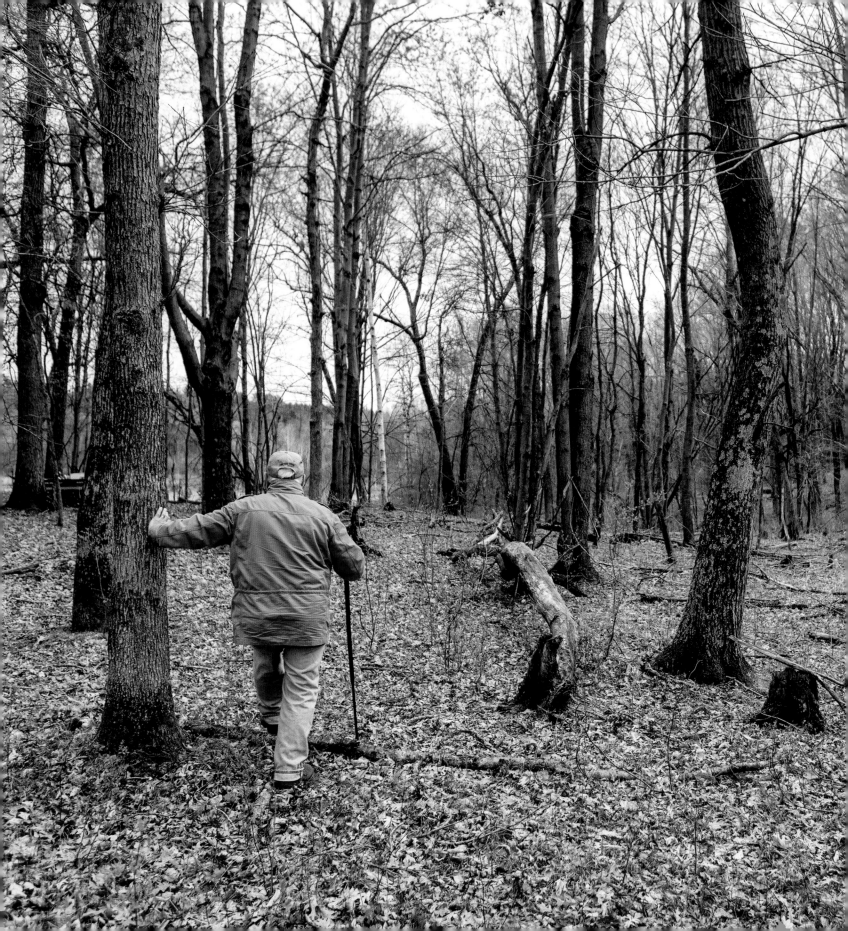

April 16, 1992

Spring is a fickle season in the North. It's not sure if it should appear, or perhaps it's shy and afraid after being so many months away. It peeks around the corner a bit, some days even coming out into the yard to play. But then, like a shy child, it retreats into the shadows, and winter returns yet one more time. Spring in the South is more forward, more self-confident. It shows its face in late February or March and stays—mostly.

April 16, 2014

Two robins, an angry looking pair, sit on the only bare ground available in front of the cabin as the recent snow slowly disappears. Their feathers are fluffed; they appear a third larger than they really are as they brave the twenty-eight-degree morning, looking for something to eat but finding little. Are they wondering if they have returned a tad early to Roshara this year?

April 18, 1971

We dug fifteen spruce trees from the home farm and hauled them to Roshara—trees that I planted in the late 1940s as part of my 4-H forestry project. We planted some along the trail to the pond, several around the pond, and a few in the gulley on the side hill above the pond. The pond is the highest I've ever seen it, even higher than last year when it nearly ran over its banks.

An electrician is wiring the cabin—soon we'll have electricity. The Coombes family, who lived here since 1912 and moved when their home burned in 1959, never had electricity but depended on lamps and lanterns, as we have done so far.

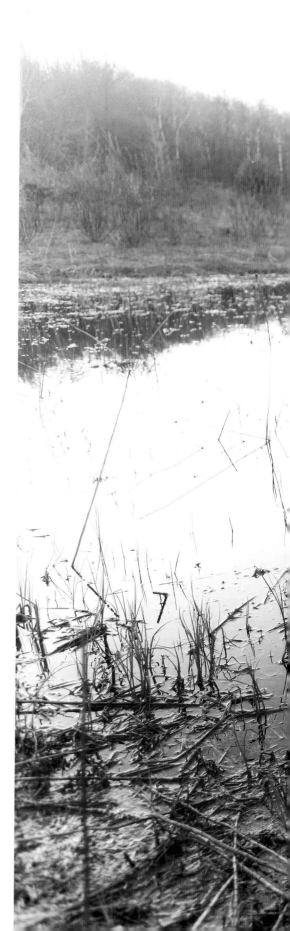

April 25, 2014

Thirty-eight degrees with rain forecast for the afternoon. I cut five black locust trees this morning to be used as posts for new bluebird houses. Sue's husband, Paul, built five new boxes, which are ready to put up— if the weather holds.

April 26, 2014

In between rain showers, Paul put up three of the new bluebird houses to replace those that have fallen off their posts, lost their roofs, or otherwise deteriorated. It's always fun to see which birds will take up occupancy. We build them for bluebirds but are happy with tree swallows. Over the years we've had a ratio of about three to one, tree swallows over bluebirds, in the several nesting boxes we have scattered around Roshara. The bird-houses are mostly strung out in a half-mile row that separates my property from my brother Don's land.

April 27, 2014

With the temperature in the mid-thirties, a stiff wind blowing from the east, and a spit of rain mixed with ice pellets antagonizing us, we planted red pine trees, little ones to replace those that died from the drought a few years ago. We hand-planted three hundred of them, a fraction of the more than seven thousand we planted four years ago. We filled in places where the drought had killed many of the trees we had planted on the top of two sandy, gravely, and very droughty hilltops. Paul and Sue and Steve and Natasha made up the planting crews. I drove the tractor with the plow, making a furrow through the thick sod to make planting a little easier. Planting the trees in the bottom of a furrow protects them from competi-tion with weeds and grass and allows for rainwater to collect a bit more. Annual tree planting at Roshara has become a ritual.

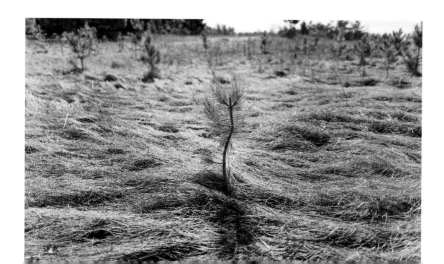

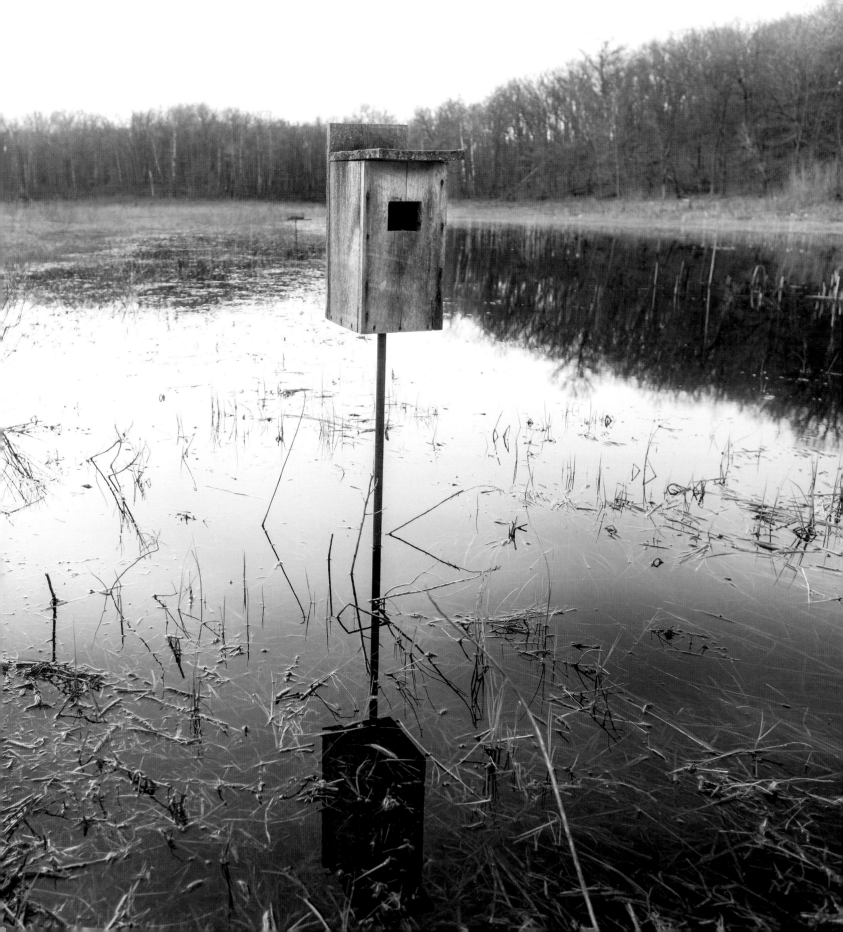

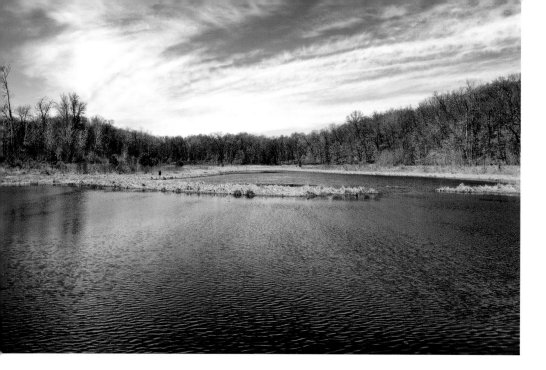

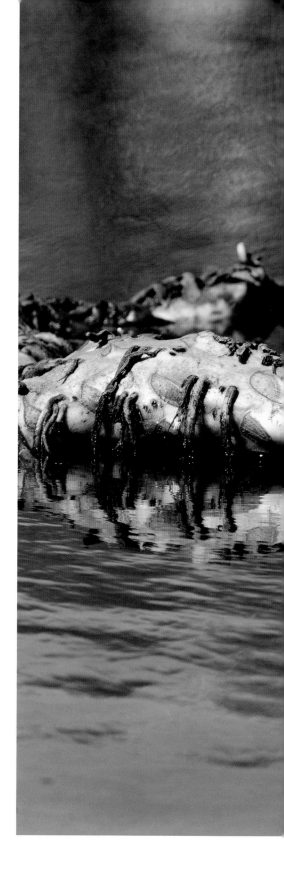

May 2, 1969

We planted one thousand trees today. Now we have four rows of red pine planted all the way around the farm. This is our fourth year of planting a thousand trees at Roshara—total four thousand trees. In 1966 we planted one thousand trees on a steep hillside at the end of the field road leading to the center of the farm. The next year we planted one thousand trees on the far west end of Roshara, along the boundary, and four rows along the east boundary near the road. In 1968 we planted yet another thousand trees, finishing the east boundary and along part of the north boundary where trees were not already growing. In 1968 we also completed planting four rows of trees along the south boundary.

In the evening the kids and I hiked to the pond—the spring peepers were singing their hearts out, telling us that spring is here. And song-birds were everywhere: cardinals, swallows, brown thrashers, red-headed woodpeckers, wrens, meadowlarks, and many more I couldn't identify.

This weekend we put up five new birdhouses—two for bluebirds, three for wrens. The wren houses we hung in trees near the cabin; the bluebird houses I wired to old fence posts in an open field.

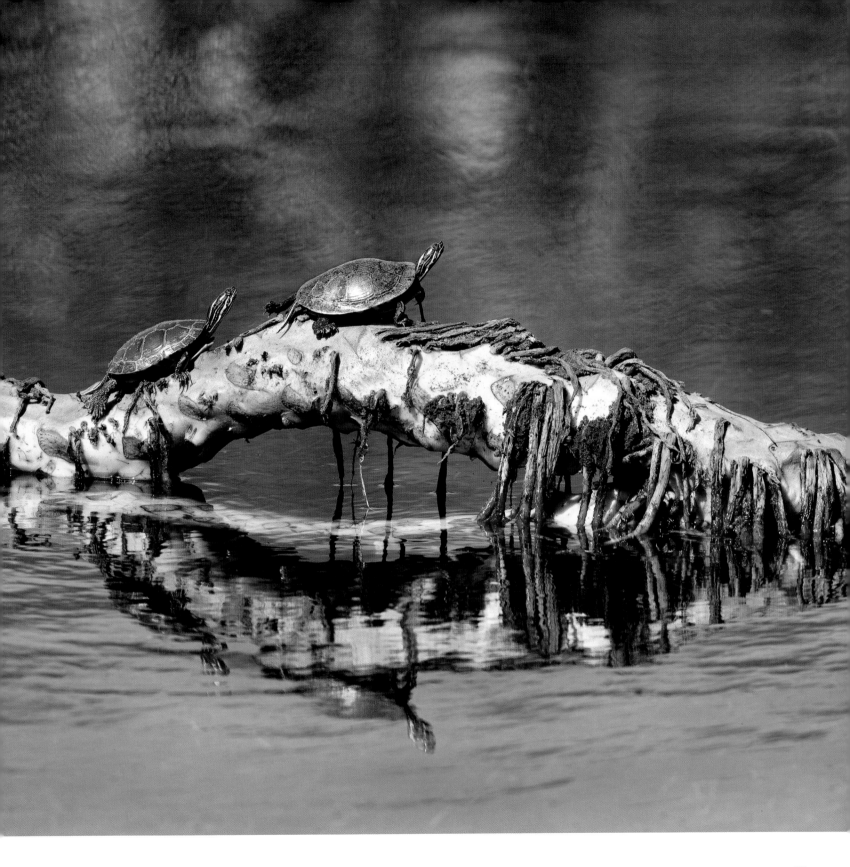

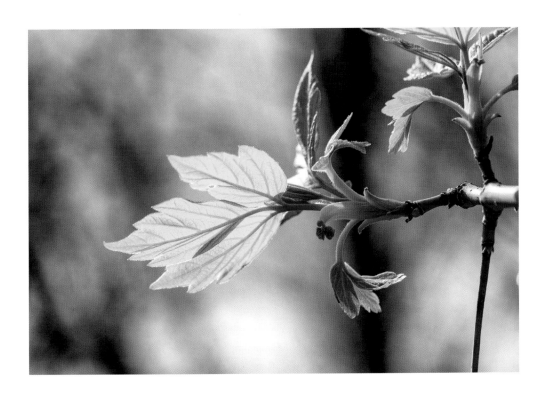

We all arrived at the farm at
6:30 p.m., Ruth, the kids, and I.
The kids are scattered around
the country: Sue in Columbus,
Ohio; Steve in Sarasota, Flor-
ida; and Jeff in Beaufort, North
Carolina. They don't see each
other very often, nor do they
spend much time at Roshara
these days.

Sunday was a beautiful,
sunny day. We had everyone
out to Roshara for lunch, Ruth,
all three kids, plus my folks.
After lunch the kids and I hiked
all around the farm, around the
pond, through the woods, in
the open fields. This was a very
special afternoon, one filled
with memories and stories.

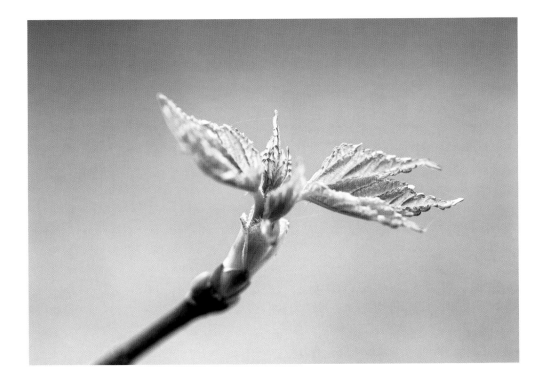

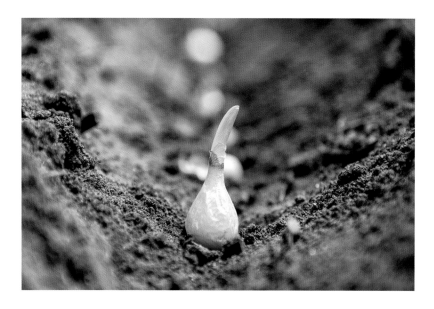

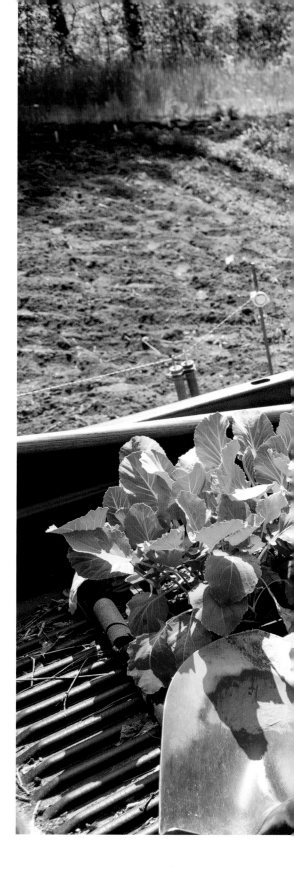

May 4, 2014

Garden planting day. Two weeks later than normal, as I like to get the cool weather crops in the ground by mid-April—potatoes, cabbage, lettuce, radishes. The whole crew is here helping, Steve and Natasha, Sue and Paul, and grandsons Josh and Ben.

The grandsons have helped with the garden since they were little tots—they are now eighteen and twenty-one. Sue and Steve have helped since they were little ones as well, along with their little brother, Jeff, who now gardens with his family in Colorado.

We have grown a vegetable garden at Roshara since 1967. These days the garden is large enough to provide fresh vegetables for three families. Gardening is one of many tasks we do at Roshara as a family, three generations working together, accomplishing the task—and having a good time. Gardening has ranked near the top for subtly teaching my children and grandchildren about nature and the importance of soil, how things grow, and an appreciation for eating food that they helped produce.

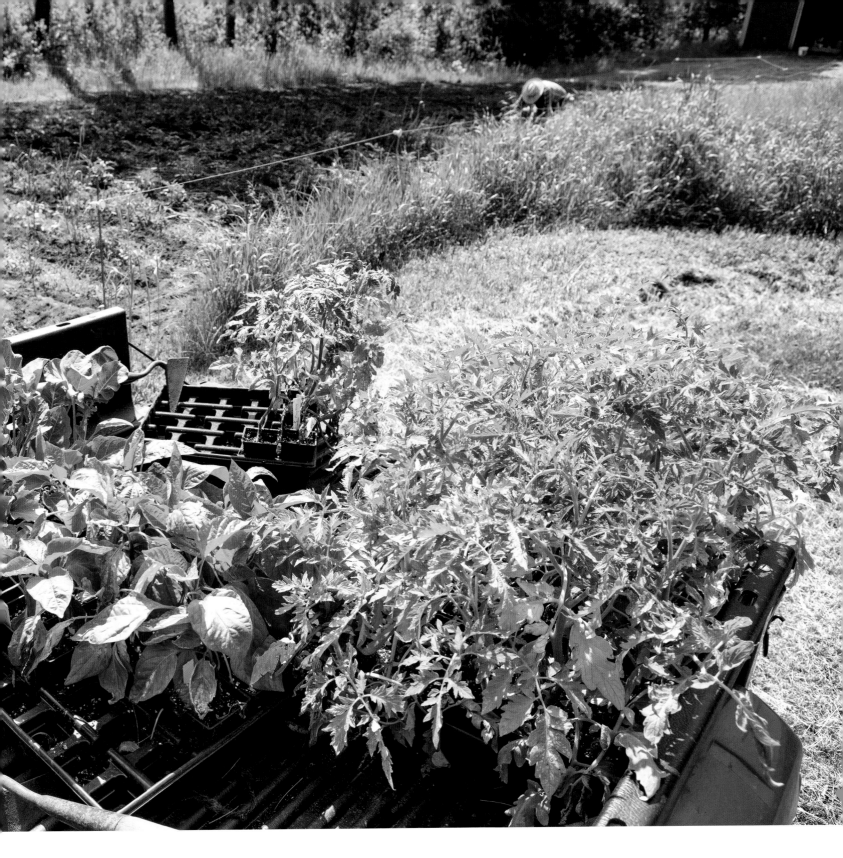

May 11, 1981

I spotted a whistling swan on our pond today, with a neck band inscribed with the number Y128. A beautiful bird that must be resting because of the strong winds last night. I wonder where it is headed.

May 12, 1992

This evening, when Ruth and I hiked to the pond, a huge turkey flew up in front of us. Soon we discovered its nest with eleven eggs. What a surprise. The turkey flock at Roshara appears to have come through the winter in good shape.

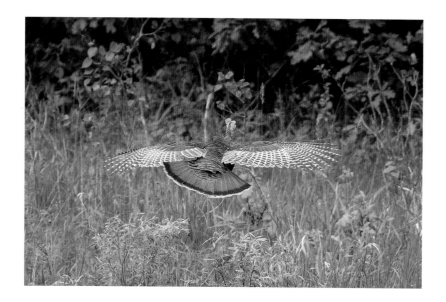

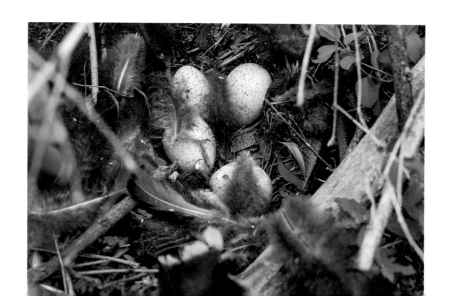

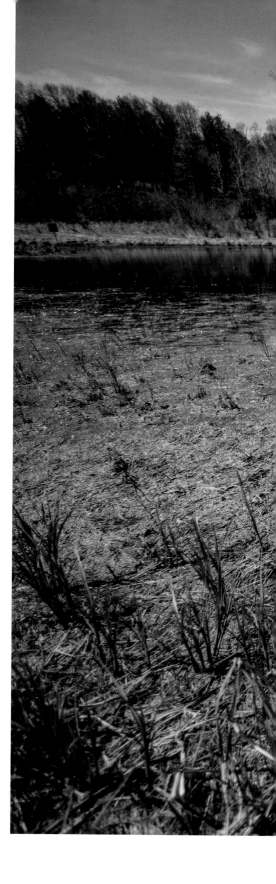

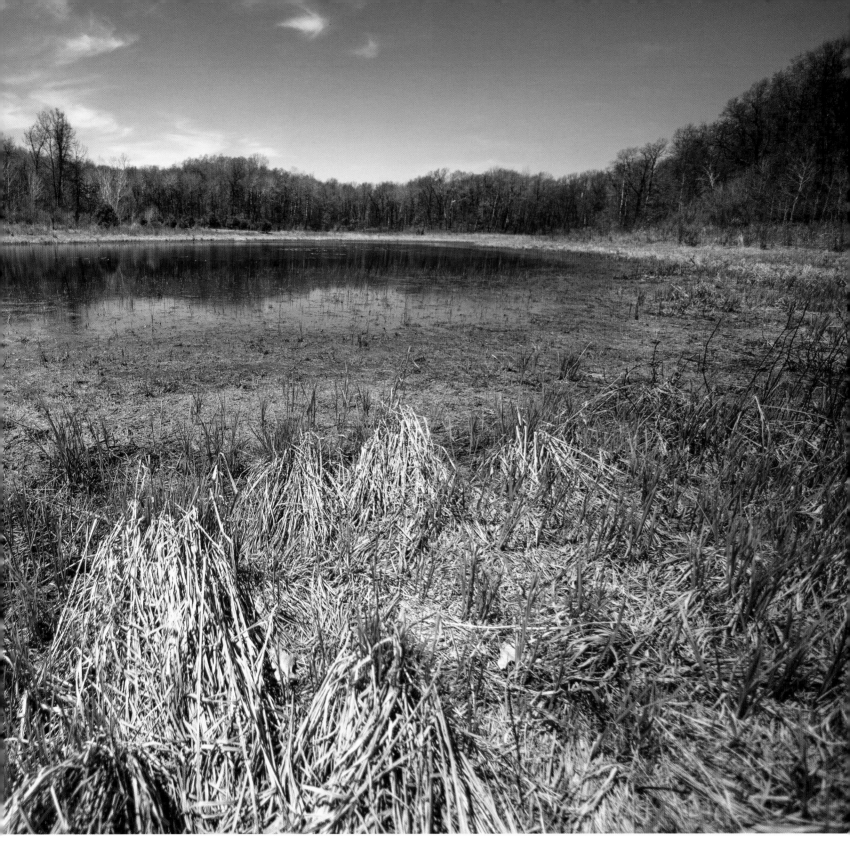

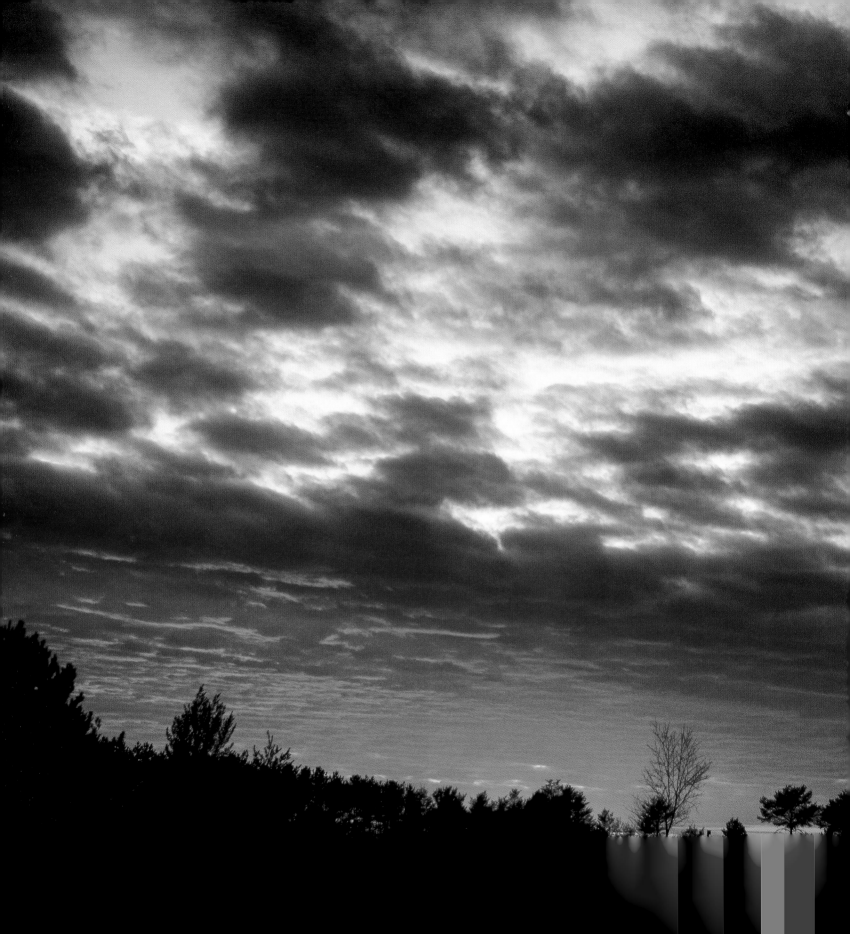

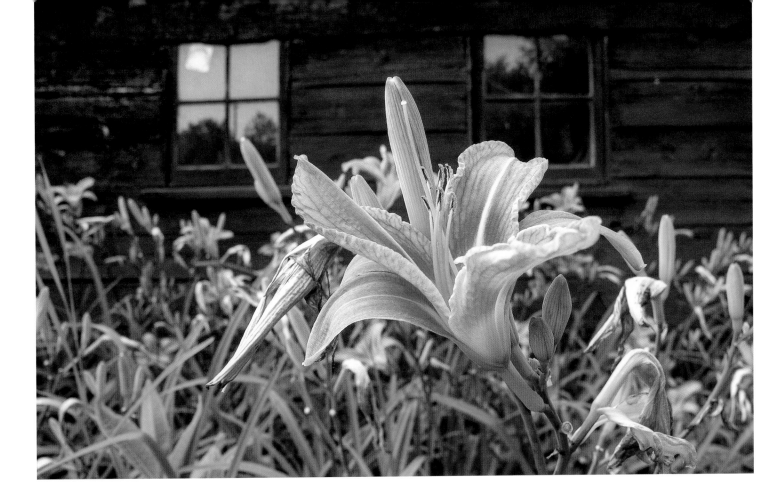

May 23, 2014

I am hunting for wild asparagus; several patches grow around the farm buildings tangled amongst the cover of orange day-lilies and prairie grass. But the asparagus is not too difficult to spot as I look for the dead stems of last year's crop. I search for green finger-size shoots pushing upward. The old pointing me toward the new—an interesting thought to ponder.

May 24, 2014

Sunset. A quiet time. Nothing stirs as I sit looking over my prairie. Not even the slightest breeze. The only sound is that of a mourning dove calling in the woods to the north. A lone mosquito flies past my ear—the first one I've seen this spring. It continues on and doesn't bother me.

Gray clouds clutter the western sky—harbingers of rain to come? Tomorrow? The next day? Occasionally the setting sun pokes through a hole in the clouds and my dull, drab prairie is once more brilliant, sparkling green—blanketed with the new growth of spring.

Tree swallows and bluebirds are working the row of bird-houses that march up the hill, one after the other, boundary markers between my brother's land and mine.

The sun is below the tree line to the west—trees that I planted in 1966. A streak of orange appears on the horizon, mixed with the gray clouds. As the sun continues to retreat, the sky turns from gray and orange to many shades of pink. As darkness slowly engulfs Roshara, I hear a whippoorwill call, again and again and again, repeating its name.

Steve, Natasha, and I transplanted tomatoes today, sixty-plus plants, tomatoes I started from seed several weeks ago. I have seven kinds, some new hybrids and some old heirloom varieties. We also planted sweetcorn, cucumbers, three kinds of squash, and a short row of dill. The garden is completely planted. Now we wait.

May 25, 2014

I'm driving my ATV along the prairie trail, looking for wildflowers and checking on the red pines we planted back in April. They are doing well, nearly a one-hundred-percent survival rate. I hear the honking of geese, many geese. I occasionally see the pair of geese nesting at my pond, but now a flock of them is flying over, in a V-formation and just above the trees. I spot at least twenty of them, honking loudly and aiming for one of my ponds to spend the night, I'm guessing. They disturb the pair of sandhill cranes nesting on Pond One. The sandhills fly up, protesting loudly, not at all sure they want to welcome a raucous flock of Canada geese to their quiet part of the world.

Are they a late flock of Canada geese flying north? This is the first time I've seen a flock of geese in late May. Always something new at Roshara.

May 27, 1992

A pair of sandhill cranes once more nests near the pond. We saw them flying over two times. What a wild, primitive call they make. I'm constantly inspired by them and pleased that their numbers are increasing after dropping to dangerously low levels.

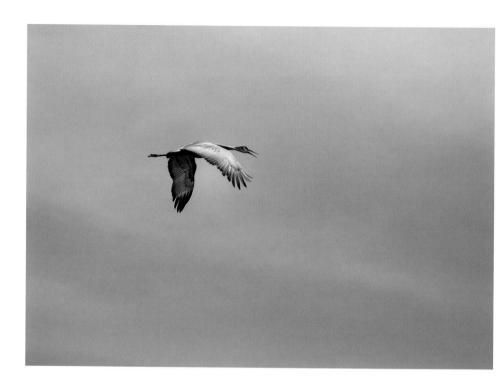

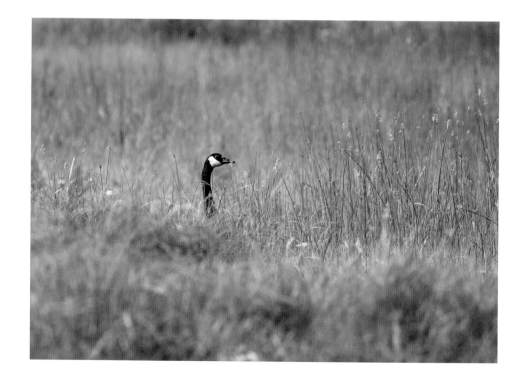

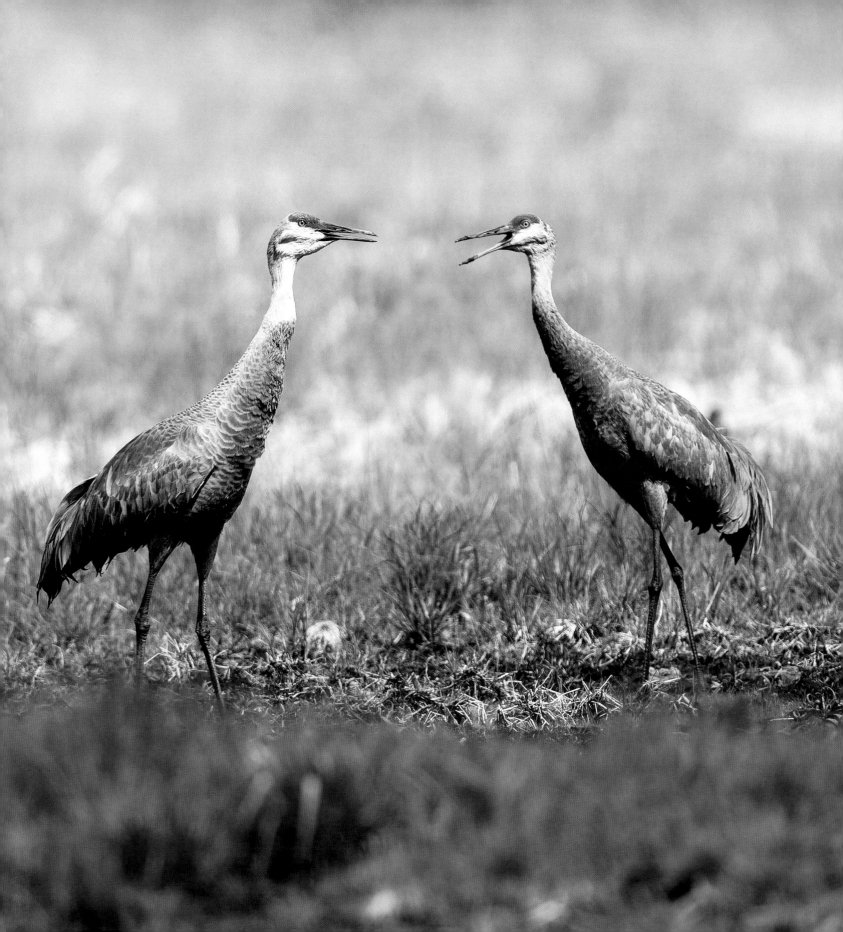

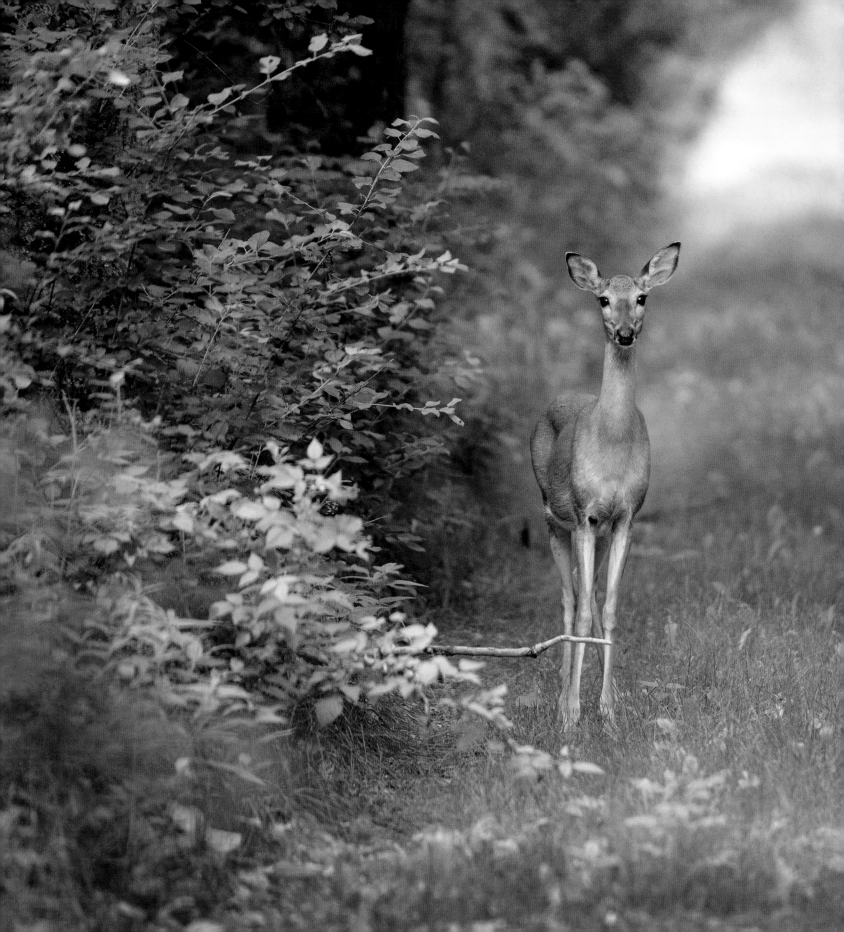

May 29, 1992

I talked on the phone with my dad last night. He informed me that about half of my tomato plants in my Roshara garden froze on Monday night. I'll have to decide if I'll replace them with new store-bought plants or plant something else. Disappointing that we should have frost this late in spring. But it happens. Part of the challenge of gardening in the North.

May 31, 2014

A world of green this last day of May. A week ago I could see a couple hundred yards into my oak woodlot. Not today. The trail is but a tunnel through the woods with so much new growth obscuring my view. The oaks and maples are completely leafed out; the new growth—little oaks and little maples—are leafed and growing. The wild geraniums are everywhere, and in the darkest, shadiest places the ferns grow tall, feathery, and graceful. As I round a bend in the trail, I spot a doe. She looks at me for a couple seconds, decides she doesn't like what she sees, and bounds away, her long white tail up and waving.

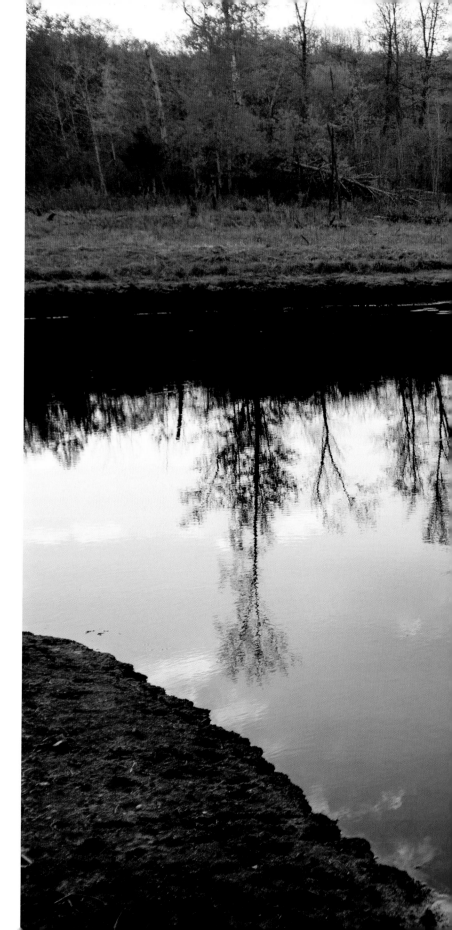

May 31, 1968

My dad and I took the three kids fishing at the pond tonight. The bullheads were biting. Each youngster caught a little bullhead as fast as Dad and I could take them off the hooks. Steve had his net at the ready (really my trout-landing net). One bullhead fell off the hook and lay on the bank and began flopping toward the water. Steve went after it with the net and was successful in capturing it, and he was mighty proud of what he had done.

"Grab it by the tail and put it in the pail" was the evening's cry. As we fished, frogs were singing their spring song. A frog jumped in front of Steve, and he clamped the net over it—so we had a side lesson about frogs. By dark we had landed forty-five bull-heads, each about four inches long. We put them all back in the pond.

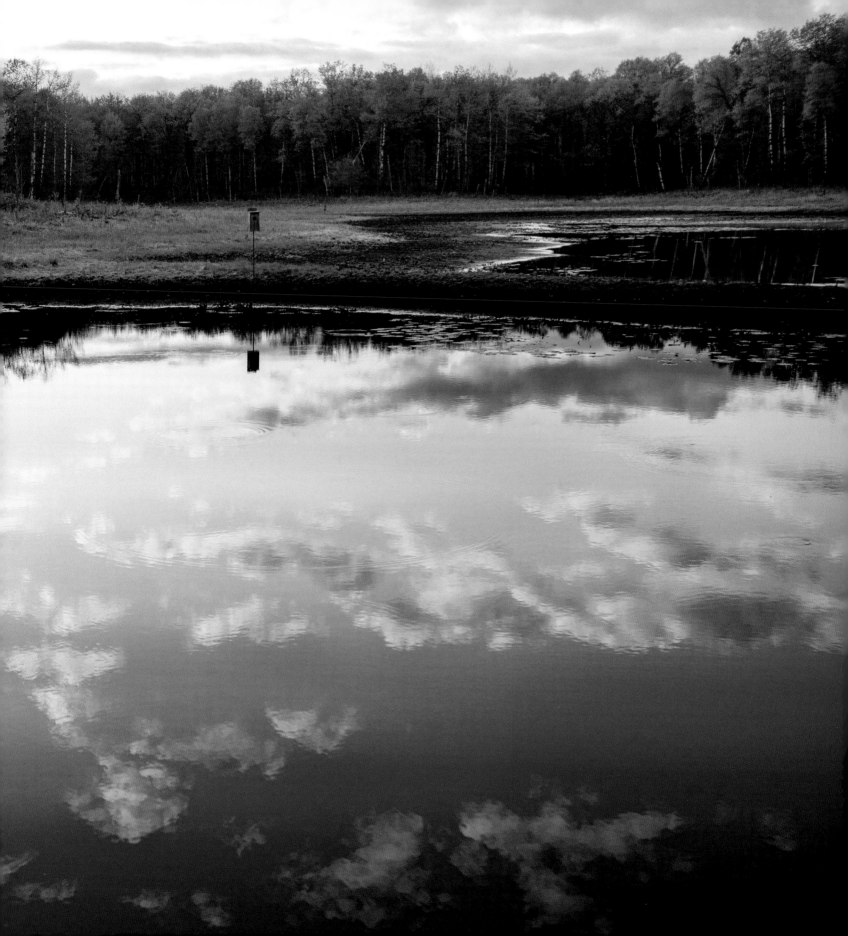

May 31, 1970

Hundreds of birds are singing at Roshara this weekend, many migrants passing through, but several wrens, cat birds, brown thrashers, meadowlarks, and Baltimore orioles have found a summer home at Roshara. I hear mourning doves calling each morning, and in the early evening the whippoorwills call and keep on calling all night long.

May 31, 1971

I saw a rose-breasted grosbeak yesterday, a first-time sighting at Roshara. I also spotted a bluebird this morning and glimpsed a woodchuck sneaking under the rubbish pile. The lilacs just west of the cabin are in full bloom—both lavender and white varieties. We were treated to the wonderful smell of lilac the entire weekend, what a delightful experience, and so filled with memories as I think about the row of lilacs that grew along the south fence surrounding the one-room country school I attended. When the lilacs began blooming we knew the school year was about to end.

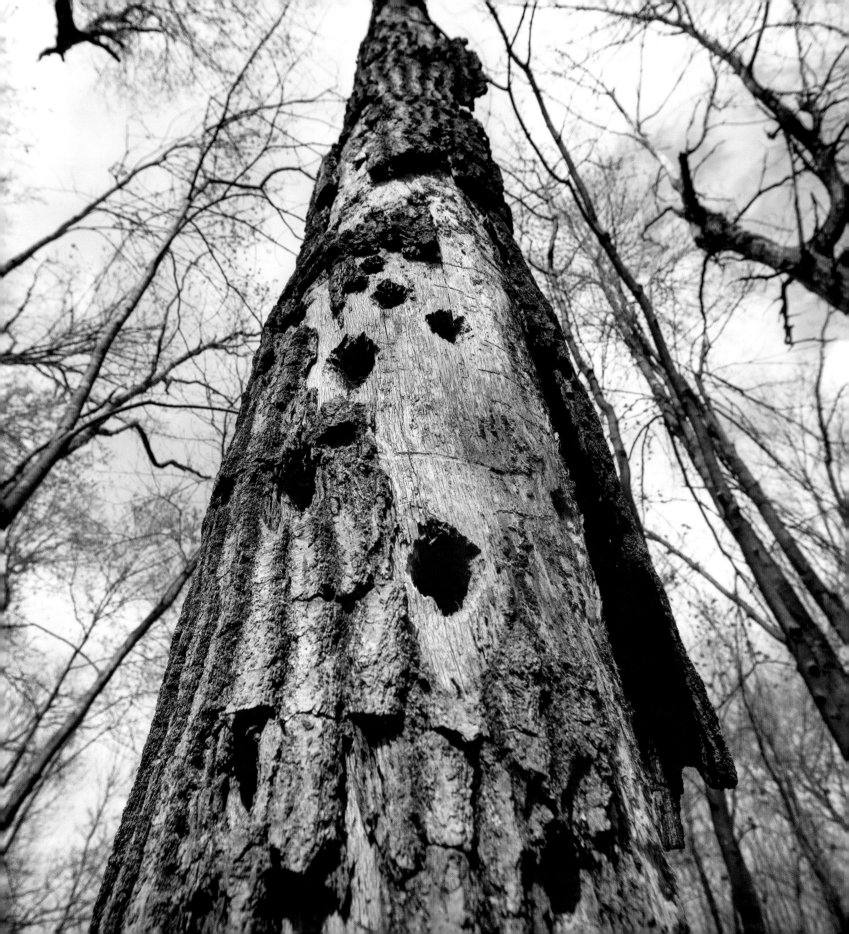

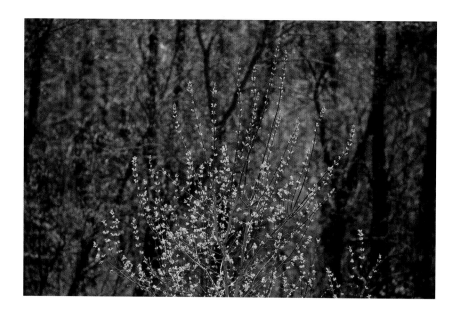

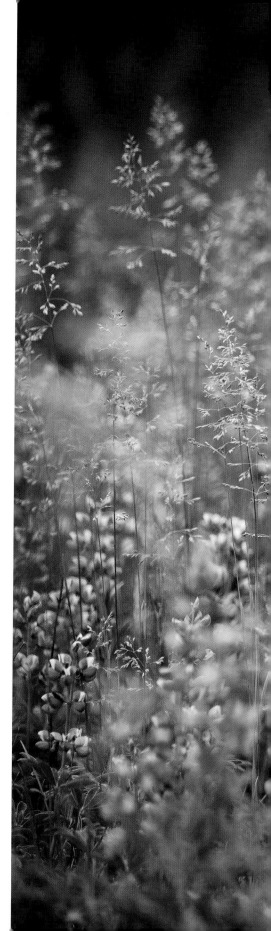

June 1, 2014

Last weekend the lupines were just beginning to bloom; this weekend they are displaying their finest. Dark purple, lavender, even now and then a white one. For the first time I spot four small patches of lupines on the hillside where the big bluestem grows. They shouldn't be growing there, as this is west of the main lupine patch, and the wind is the primary agent for distributing the seeds as it mostly blows from the west and the southwest. But here they are. One more surprise at Roshara.

June 14, 2014

Rain gauge at Roshara reads three inches, all having come in three days. A little erosion on the field trails, but not serious. Rain is always welcomed, even when it comes quickly and in large amounts. Our sandy soil appreciates it. Roshara's plants and animals appreciate it. And the ponds certainly appreciate the recharging.

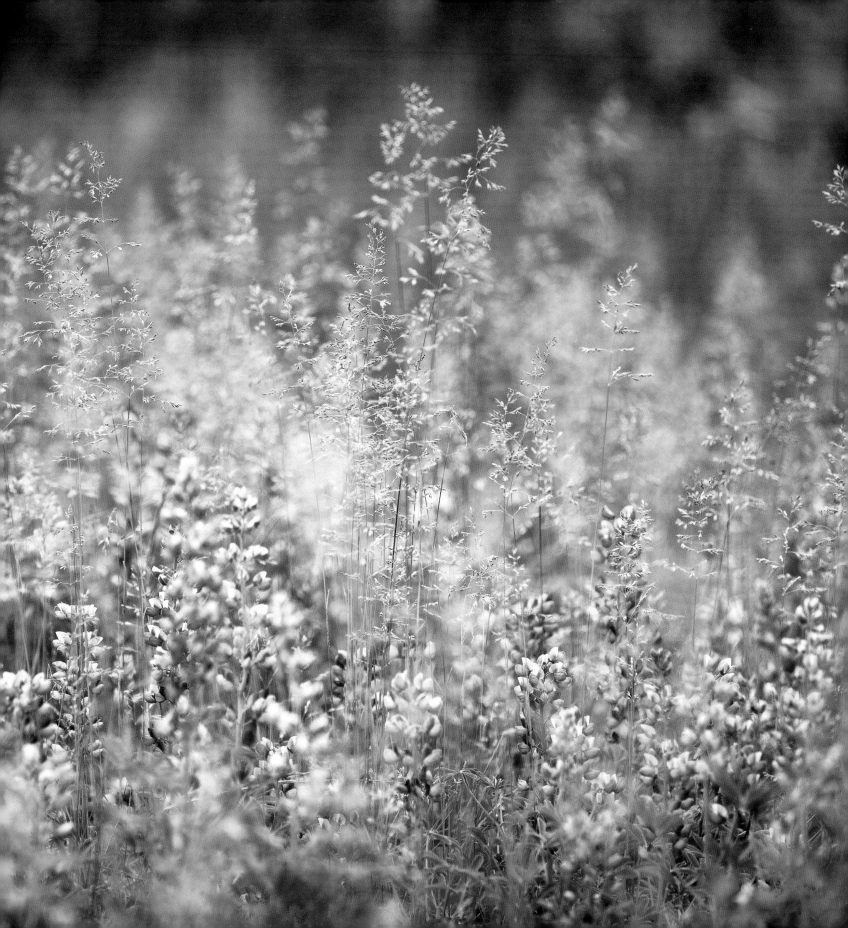

Summer

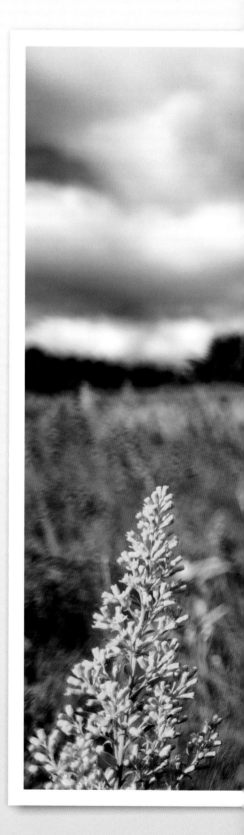

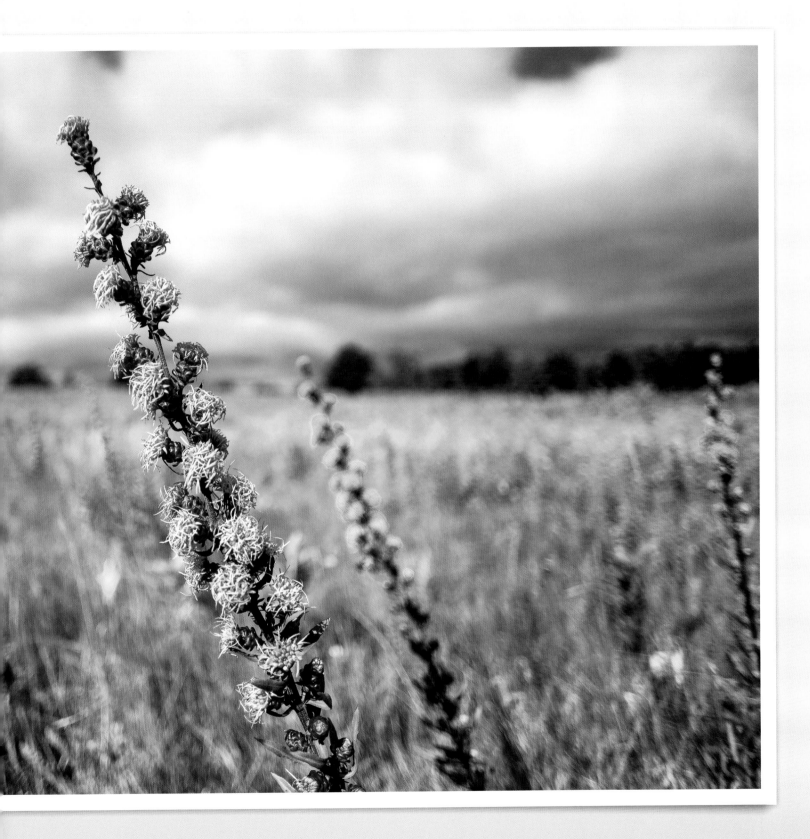

June 21, 2014

I'm at the far corner of Roshara, deep in my oak woods on a cloudy, dreary first day of summer. This is one of those rare places where electronic devices do not have much presence. Cell phones work reluctantly—best reception is in Steve's deer stand high up in an oak tree. "You live in a 'dead zone,'" a cell phone salesperson told me.

So the distraction of constantly checking for emails and text messages is not possible. For those who have become addicted to these time-consuming little monsters called smart phones, devices that keep us constantly connected, visiting Roshara can be an annoyance. For some, becoming disconnected is a near catastrophe. Being alone in nature with all of its sights and smells and subtle sounds can be a welcome tonic for those suffering from electronic addiction, a disease to which many people these days have succumbed.

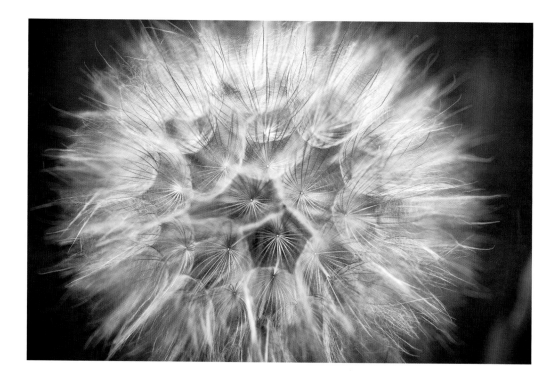

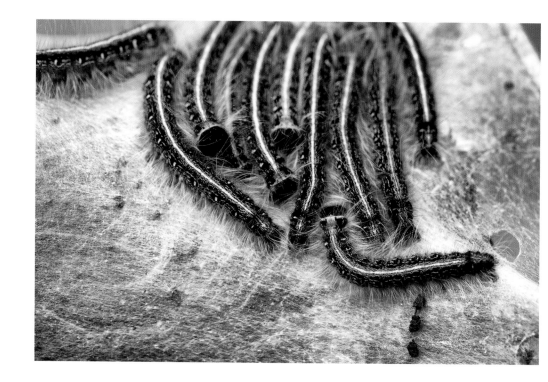

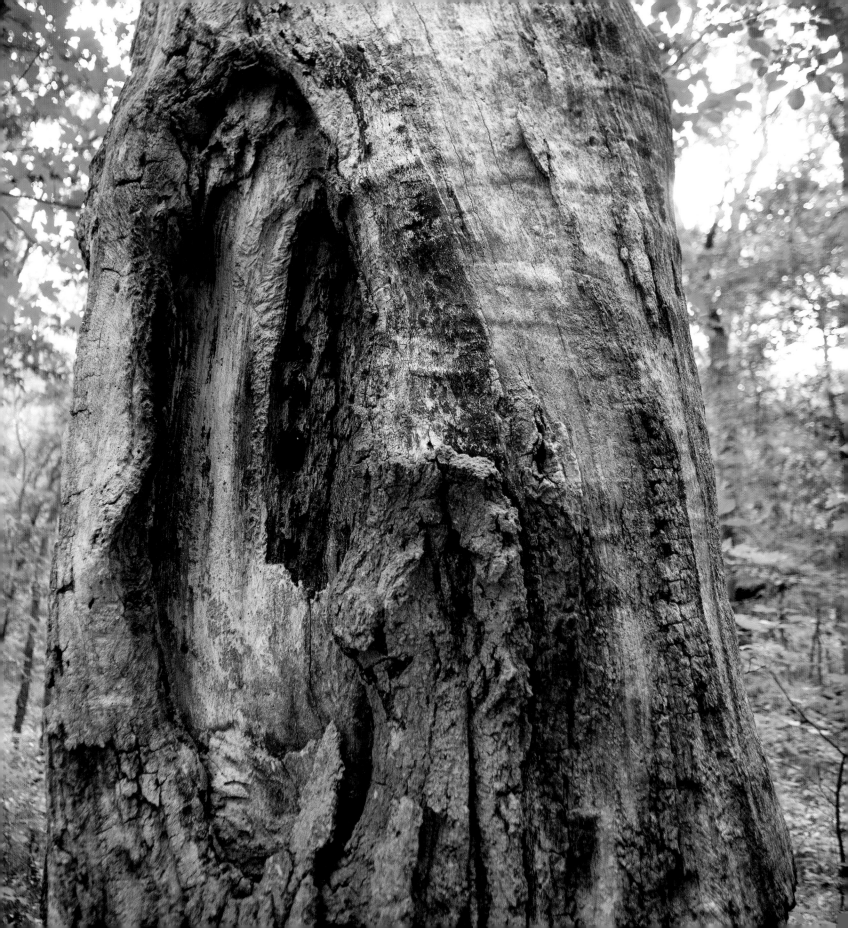

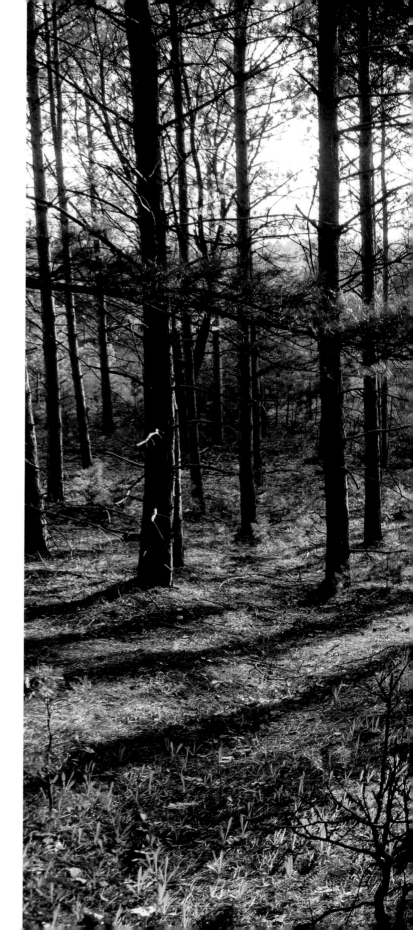

June 22, 1971

Oh how time speeds by in these first days of summer. Each day seems to dawn faster than the previous. I'm sure the progression of days is as it has been for eons, so the change must be me. Is this a sign of getting older? I read that someplace.

June 24, 1982

This afternoon I tied little cheesecloth bags, each containing one or two mothballs, to the fence all the way around the garden to keep the deer away from the vegetables. It's a primitive fence constructed of locust posts cut at the farm, one string of wire, and now moth balls. Will it work?

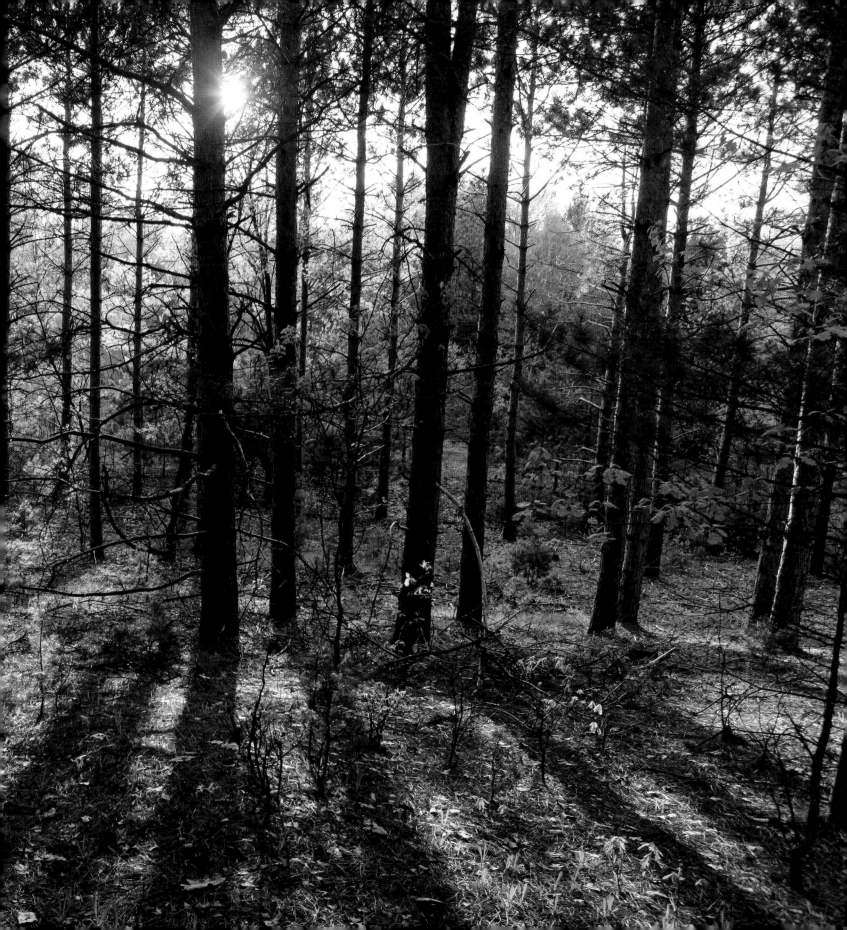

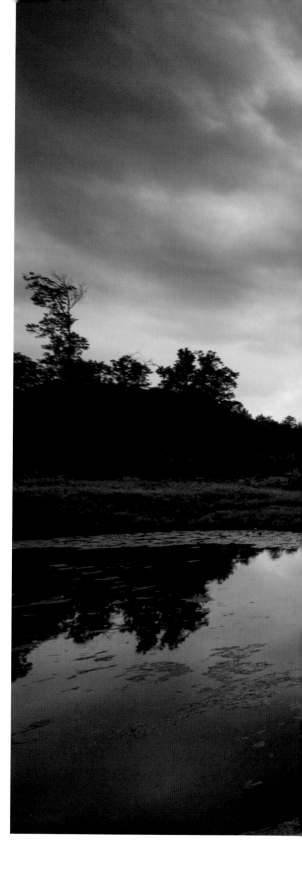

June 26, 2014

I'm sitting by Pond One just before the sun slips behind the trees to the west on what has been a warm, sultry afternoon. Dark shadows of the oaks and maples creep across the pond's smooth surface, broken occasionally by a water bug skittering here and there. The silence is deafening, no breeze, no birdsong, nothing. Then I hear a mourning dove call to the west, breaking the silence.

I watch for baby ducks, for baby geese, for baby sandhill cranes. But I see nothing, just very tall grass the heavy rains the last few weeks have encouraged. Grass taller than I am and so thick that if I stray from the narrow trail I become entangled in it.

Horse tail clouds surrounding the setting sun suggest more rain within the next several hours.

June 30, 1981

Beautiful, warm summer day. Temperature in the eighties. I finished staining the exterior of the cabin last week. Looks great once more. With rains, the garden is growing and the lawn is once again green. My old friend L. G. Sorden died last Saturday at age eighty-three. He had been a county agricultural agent in Oneida County. One of his favorite sayings about dry weather: "It's so dry in the north this summer, the rivers only run on Tuesdays and Thursdays."

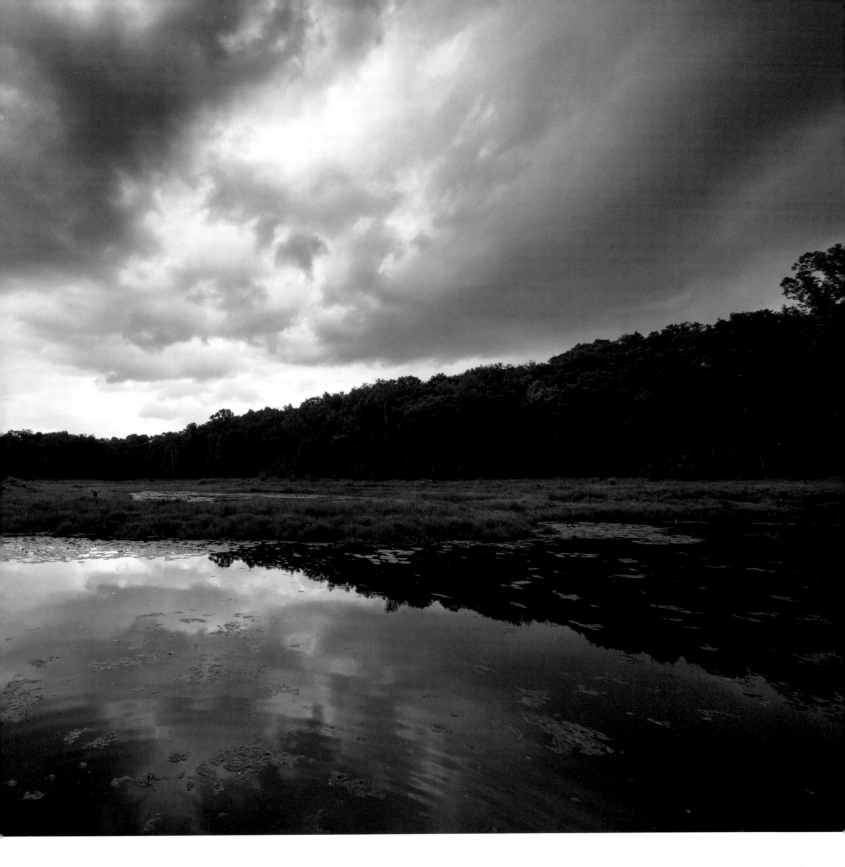

July 4, 2014

Six-thirty a.m., 46 degrees. A cool morning after nearly a month of hot, sultry weather. But no complaints as the ample rainfall has the vegetable garden welcoming every drop of rain, as are the little pine trees I planted last April.

A pair of wild turkeys walks by the cabin, picking up bugs as they slowly move along, always looking and listening, always wary.

I am up early as the whippoorwills have insisted on calling all night long. I awoke just before sunrise and heard one calling nonstop, again and again and again, apparently wanting to complete its calling before the sunrise, after which it will rest until evening.

Dew hangs heavy on everything this blue-sky morning, on the garden vegetables, the potatoes, and the more-than-knee-high corn, on the tomatoes and peas that are ready for picking, and on the big leaves of the vine crops that are slowly filling the spaces between the rows.

July 5, 2014

So far, one of the best garden seasons I remember. The early potatoes are soon ready to eat; the late potatoes fill the rows, more than knee high and in blossom. No need for more cultivating or hoeing; the heavy foliage crowds out any weed that may be looking for a smidgen of sunlight in order to grow.

We picked the first batch of peas yesterday—oh what flavor in these fresh-picked peas. I pulled a few onions, ready to eat, but they will double in size in the next month. Tomatoes are a little slow, but of the forty-five plants we set out a little over a month ago, some forty-two are growing well. Almost all are in blossom, with the early varieties showing a few tiny, immature, green tomatoes. Sweet corn is well above the obligatory "knee-high by the Fourth of July." Green beans are soon ready for picking; so is the zucchini.

Timely rains and warm temperatures are what Roshara's sandy soil requires, and that's what we got for the entire month of June.

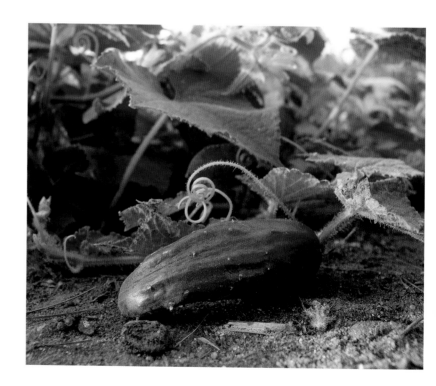

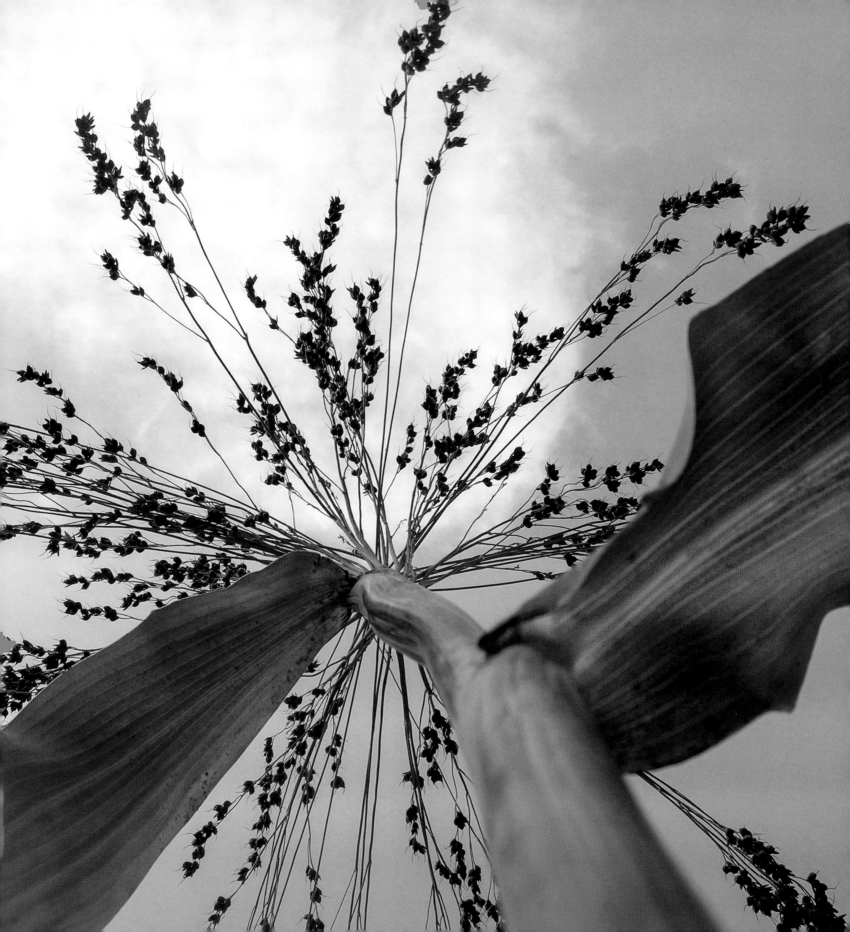

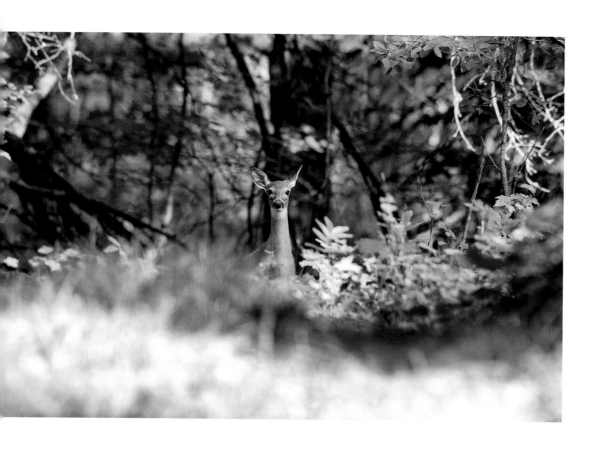

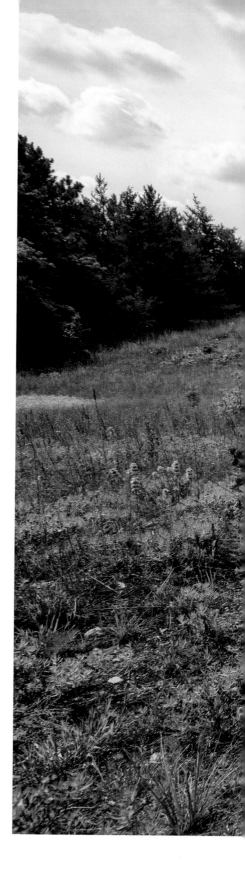

July 5, 2014

Don and I are slowly traveling the trails around Roshara, through the deep woods, up and down the steep hills, stopping occasionally to listen, to wait and to watch. As we round a sharp bend, standing next to the trail no more than a dozen feet away stands a big doe, looking right at us, her big ears flicking back and forth. She watches us for half a minute or so and then decides she has seen enough, bounds off, and only then do we see that two more does and a fawn are with her. They hurry away from us, but they do not seem unduly alarmed. Their coats are reddish brown and slick—lots of lush grass to feed on so far this spring and summer.

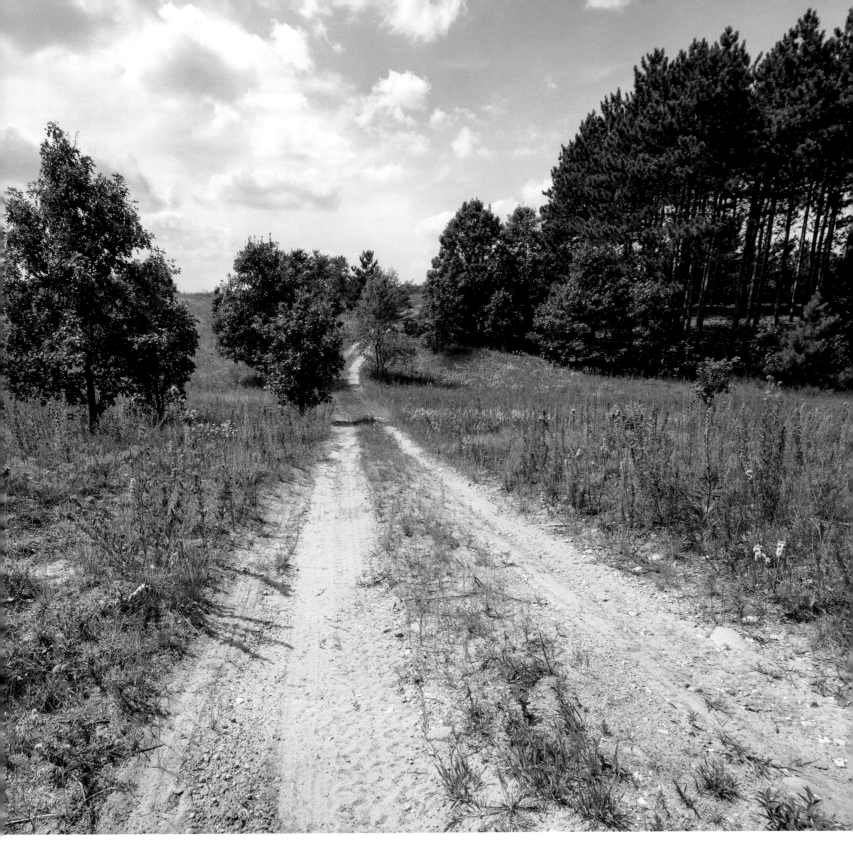

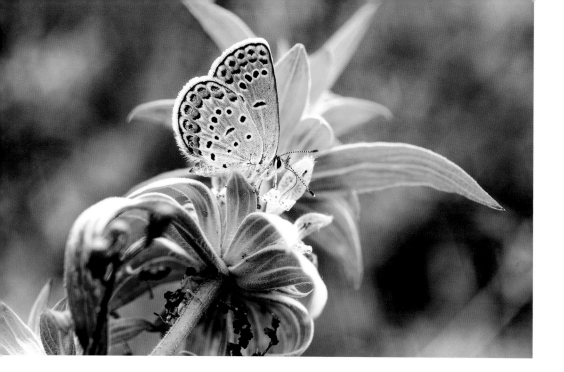

July 6, 1970

I mowed the tall grass around the cabin so the kids could play in the morning without getting wet—mowing also keeps down the mosquito numbers. The children and I took several hikes. We found a ground bird nest with three eggs.

 I noticed something unusual with the oak trees in the woodlot to the north of the farm. In early May, a late frost killed back the new leaves as they were emerging. By Memorial Day, many of the oaks nearest the pond were once again getting new leaves, while the oaks farther up the hill already had fully leafed out as they had not been touched by the frost. I noticed some of them looked like fall had already arrived. Upon closer inspection, I saw that the green material from the leaves had been chewed away, leaving only the leaf veins. Holding a leaf to the light, I could see the entire veining with nothing in between. It will be interesting to see how many of the affected oaks will survive this massive insect attack.

July 6, 1971

On our hike around the farm, the kids and I found six eggs in a tree swallow nest in one of our bluebird houses. Very warm, near 90 degrees the last three days.

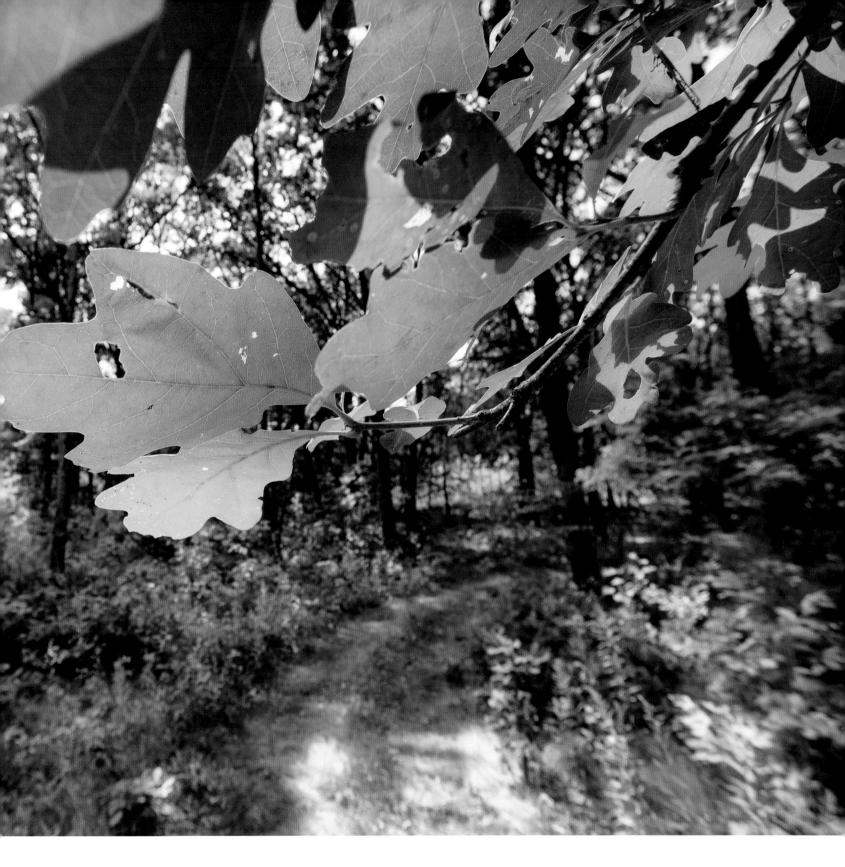

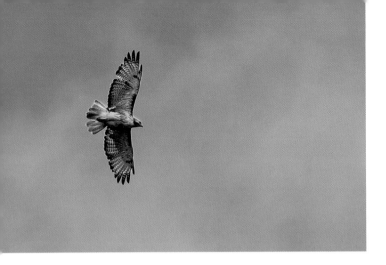

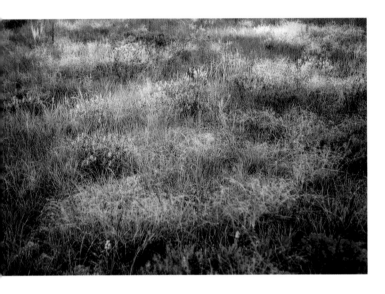

July 19, 1967
Oh how these summer days slip by. We wait
for spring that never seems to come, and then
summer is half past before we have time to
think about it being here.

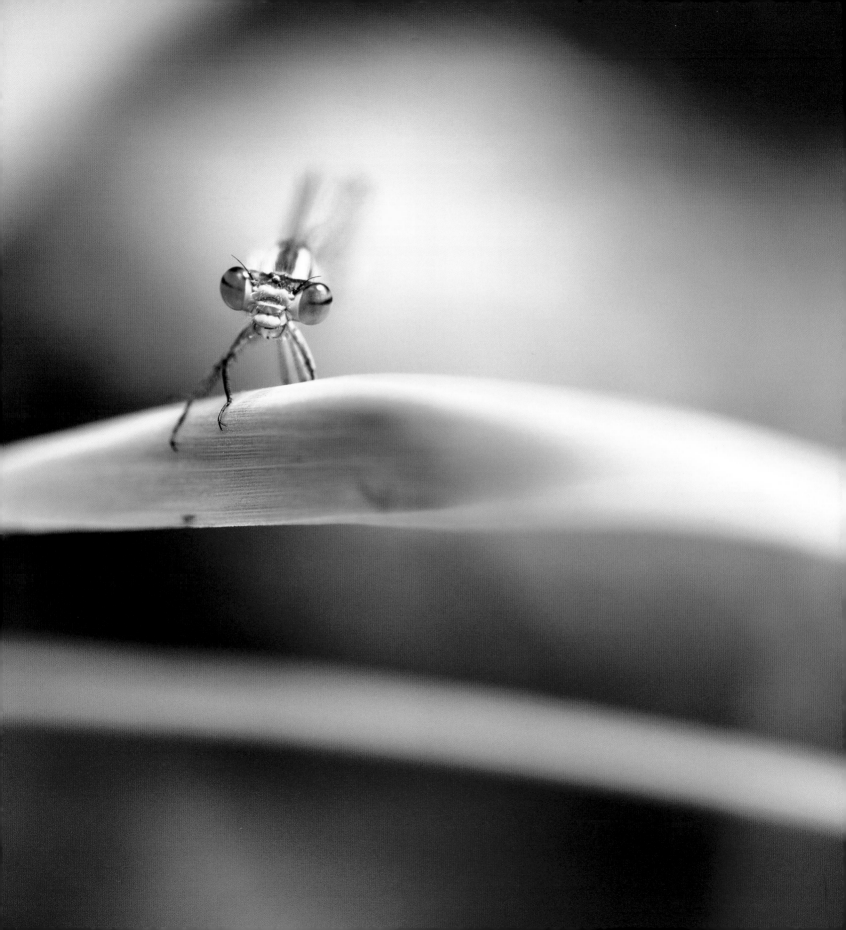

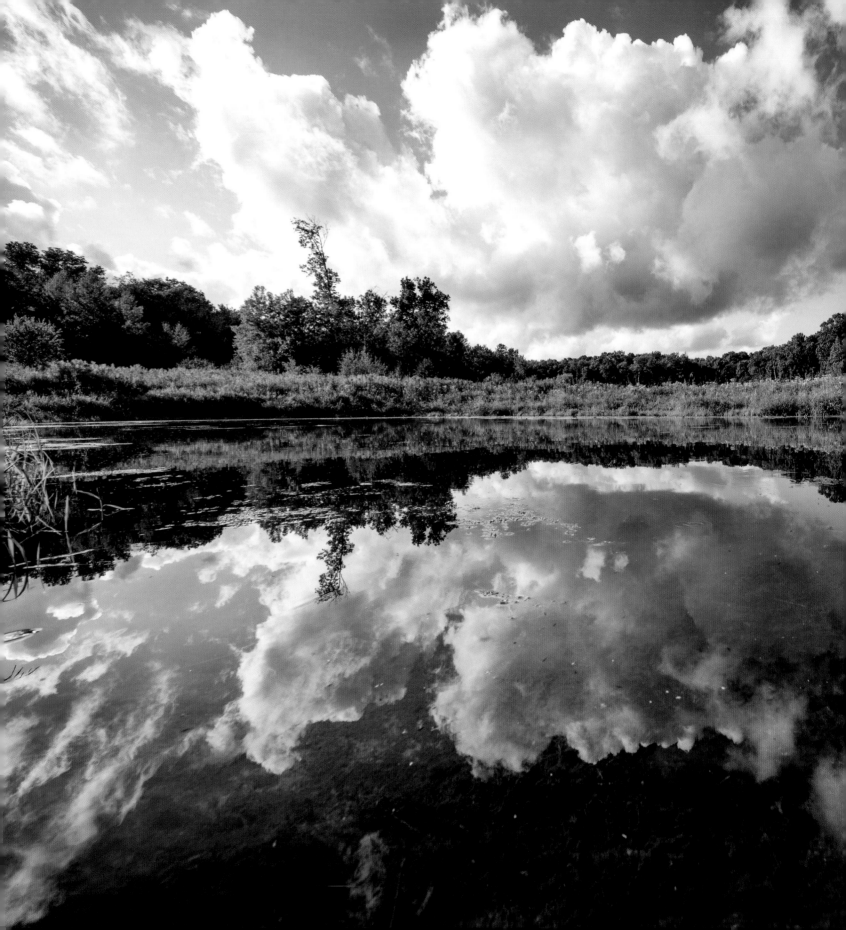

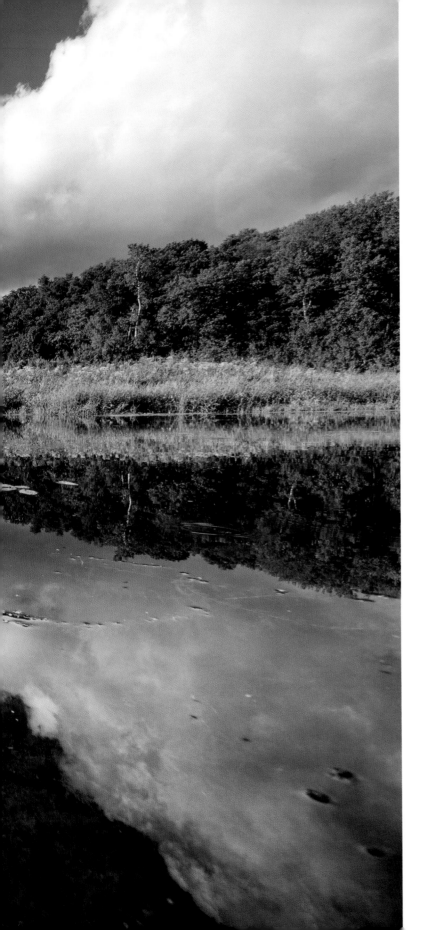

July 20, 1970

Swallows built a nest in the pump house and hatched five little ones. They have grown enough so that they are taking flying lessons. The last couple of evenings the little ones huddled together on the roof of our cabin. Fear of flying?

Box elder trees are one of the worst weeds we have at Roshara, especially around the buildings. Every year I cut off several of these pesky trees, and the next year two or three new shoots emerge to replace the ones I cut. Where we tore down the old barn in 1967, now but three years later stand a couple box elder trees that are fifteen feet tall. The older trees have great numbers of seeds that float on propeller-like appendages that send them scattering widely. It seems wherever a seed lands on the ground, a new box elder tree grows. Not to mention the box elder bugs that are attracted to these trees and make their way into the cabin, with a nasty smell.

July 20, 1973

Flooding along the Mississippi River. Entire towns are underwater: Davenport, Iowa, and Quincy, Illinois. Farmland along the river is a huge lake. This is one of the most serious floods in many years. Baraboo received seven inches of rain last Saturday evening. Central and southern Wisconsin has many flooded basements, and lakes are high everywhere. Our pond is several feet higher than just a couple of years ago. The water level is approaching the highest I've known in the time we've owned Roshara.

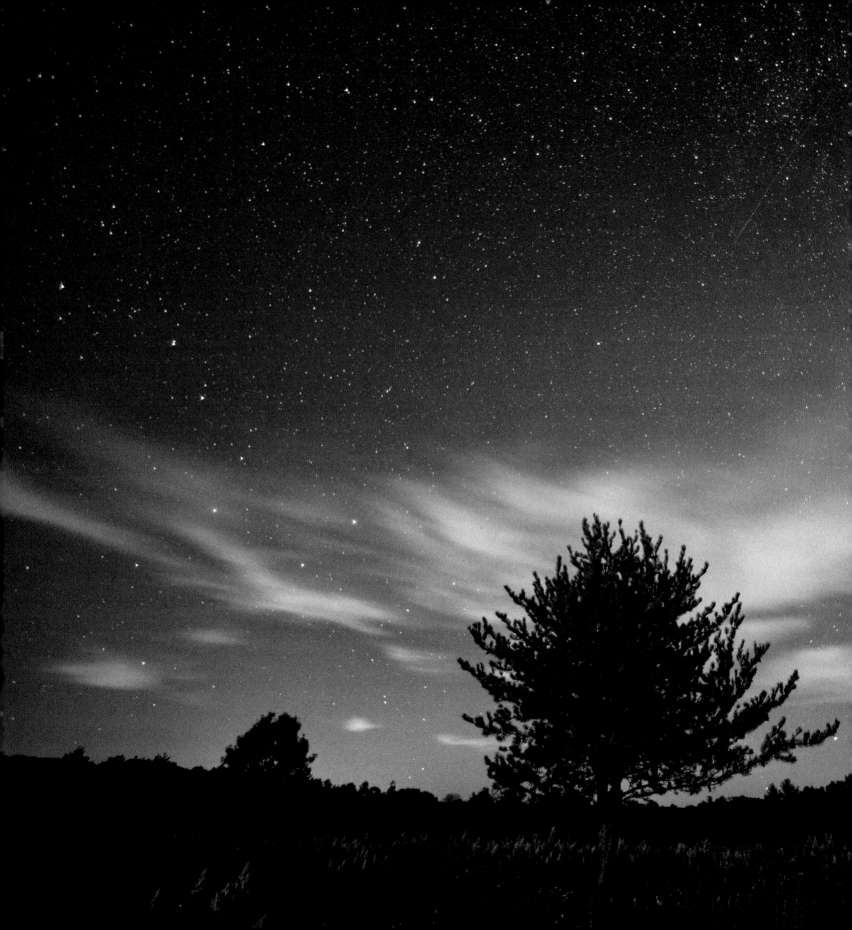

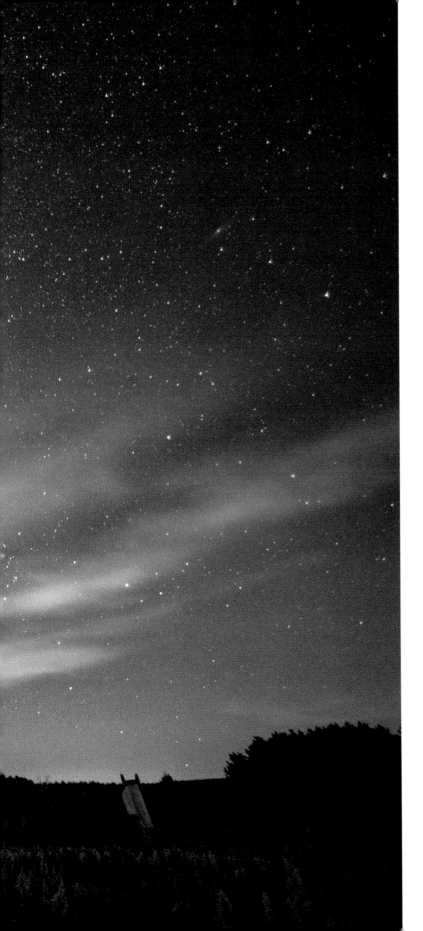

July 22, 1968

Beautiful day. Clear. Temperature in the high eighties. Last night the whippoorwills were calling. One landed in a tree just above our tent and thrilled the entire family. We heard a deer snorting and then caught a glimpse of it. An owl called in the woods to the north. A few horse tail clouds in the western sky turned from pink to lavender and finally black as the sun slipped beneath the horizon. Threads of steam lifted from the pond, creating a misty cloud over the valley. Smoke from our campfire rose twenty feet into the air, bent 90 degrees, and trailed off to the south. I spotted bats swooping and diving as they plucked mosquitoes from the air. Finally it was dark enough to view the expanse of stars stretching from horizon to horizon. And then, the only sound we heard was that of crickets that reminded us that autumn must be on its way. But in July?

July 23, 2014

Dry weather at Roshara, and hot as well—92 degrees yesterday, first time above 90 degrees this summer. Very humid. A cold front raced in from the northwest, but no rain. Not even a cloud.

Today it is 71 degrees at noon. A cloudless sky and not a hint of a breeze. The beginning of the dog days of summer. I'm watering the garden, which has so far looked good but is beginning to show the strain of too little rain.

July 24, 1968

The hillsides are beautiful this summer. With ample rain the usually dry sandy knolls are now alive with wildflowers and assorted other plants: sand vetch, black-eyed Susans, yellow and white clover, showy milkweed, goldenrod, red clover, and more that I can't identify.

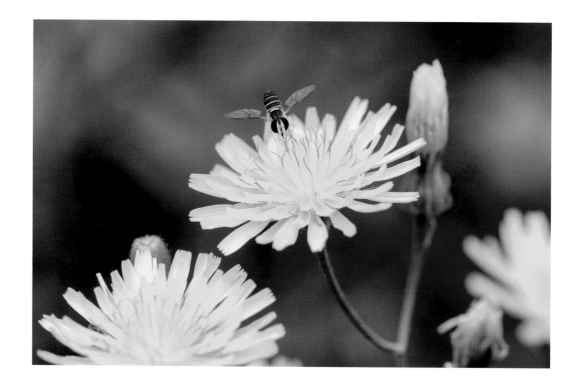

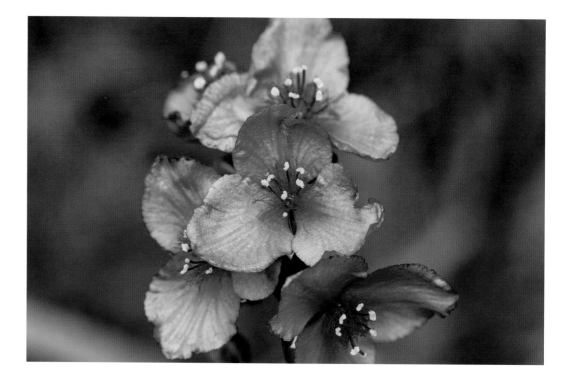

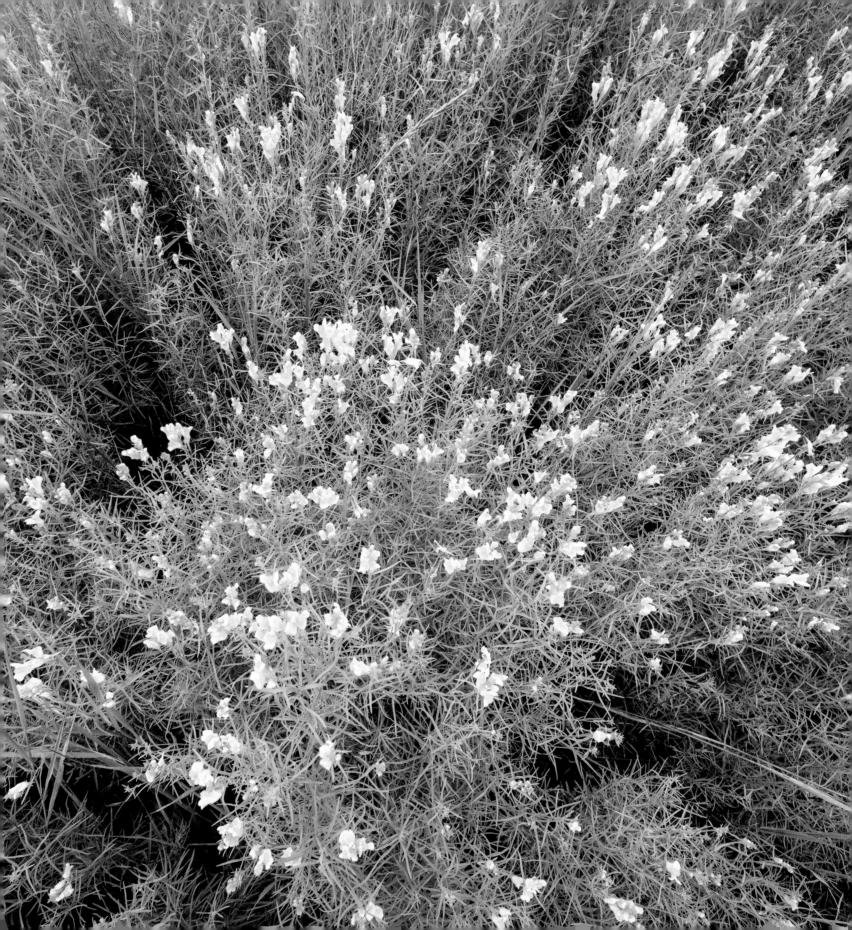

July 24, 1993

Dad died at 10:30 last night. He would have been ninety-four years old on September 21. I'm still not past the shock of it. I talked and joked with him just a week ago today. When I visited him in the hospital earlier last evening, he didn't respond when I tried to talk with him. He wasn't fighting death but in some unknown way seemed to be looking forward to it. Dad got what he wanted—he resisted even thinking about living in a nursing home. When I last talked to him, he said he wanted to die in his sleep. That is what happened.

Dad was an outdoor person. He enjoyed hunting and fishing and continued these interests until this past year. He deer hunted with us last fall, when he was ninety-two. When my mother died in April, a lot of my father died as well. She had been one of his big reasons for struggling on.

I want to remember some of what Pa taught my two brothers and me:

> *Let your deeds tell your story. Don't blow your horn too loudly, just loud enough so people won't run over you.*

> *Do the best you can with what you've got.*

> *Always be yourself. Be real. Don't pretend. Always tell the truth.*

> *Love the earth, but respect it, too.*

> *Avoid spending too much time indoors. Dig in the earth. Sit under a tree. Walk in the woods. Split wood. Watch a deer.*

> *Watch the sunset each evening. It tells you about tomorrow's weather, but it also helps you celebrate the day's end.*

> *Live a simple life. Eat plain food. Wear plain clothing. Avoid collecting too many "things."*

> *Enjoy a thunderstorm. Be impressed with the power of lightning and never curse the rain.*

> *Savor a dipper full of well water on a hot day in July.*

> *Grow a big garden.*

> *Go fishing. Don't be disappointed if the fish don't bite. Catching fish is only a small part of the joy of fishing.*

> *Appreciate a good story.*

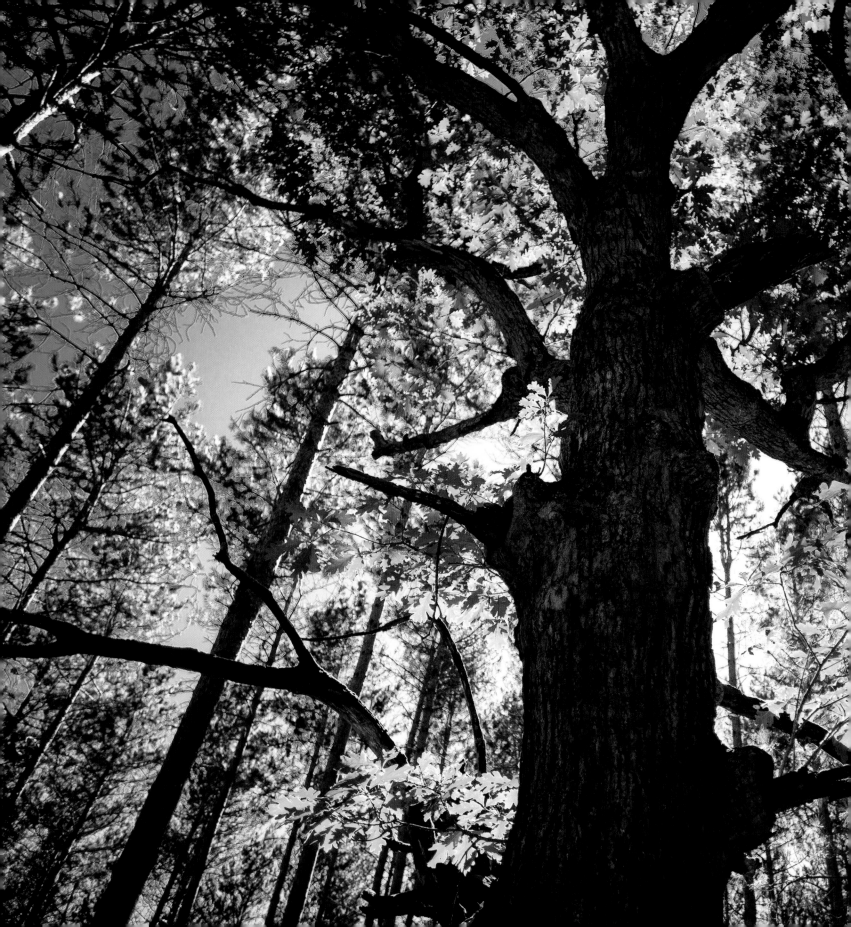

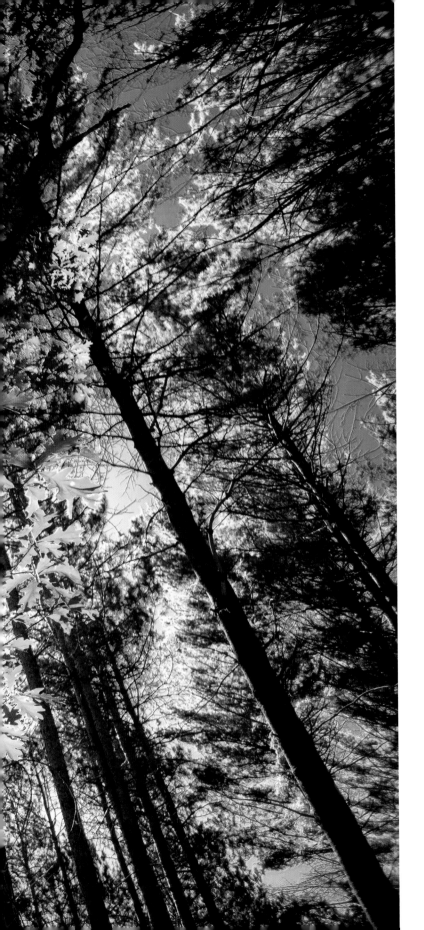

July 25, 1970

My birthday—thirty-six years old today. Sue (eight), Steve (seven), and Jeff (six) found an anthill in our woodlot on the far west end of Roshara. They had never seen an anthill before. They got right up to it, and before they realized what was happening, ants were crawling over their feet and up their bare legs. They brushed off the ants, trying to rid themselves of these interesting insects.

July 25, 2014

My birthday. Eighty years old. Hard to believe. I remember when an eighty-year-old was considered "really" old. Today, I know several people in their nineties—very active people, my role models. Someone told me eighty is the new sixty. A pleasant thought.

My forester arrived this morning at eight. Together we plan for the eradication of more evasive plants at Roshara, especially black locust, buckthorn, honeysuckle, and hybrid maple. This is the third year we have declared war on these troublesome invaders—we are making progress, slowly.

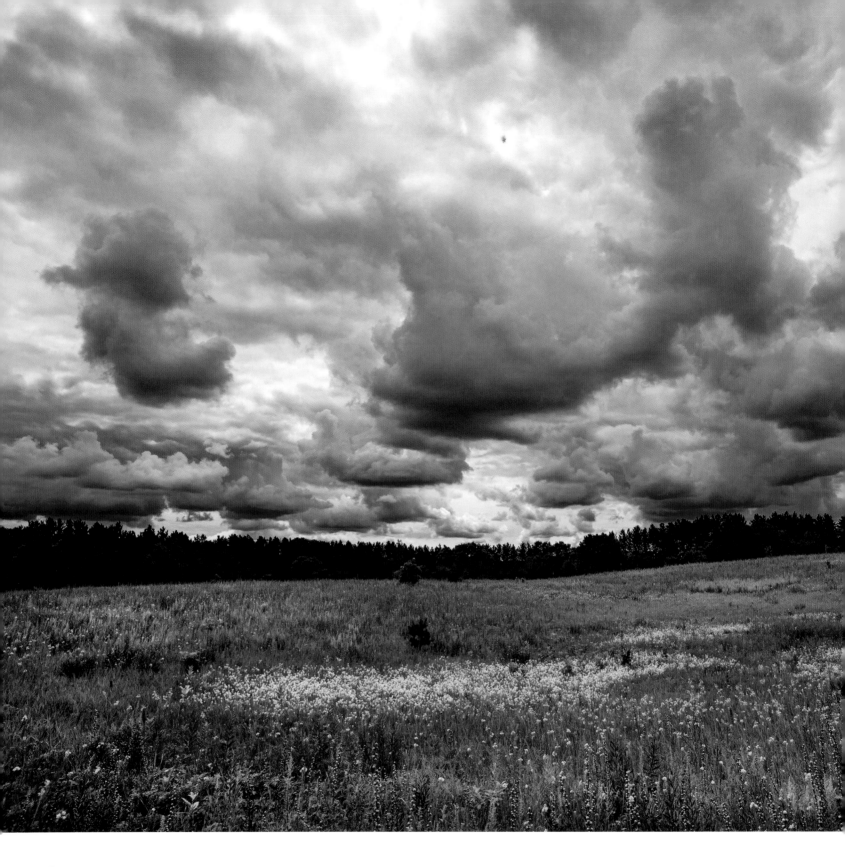

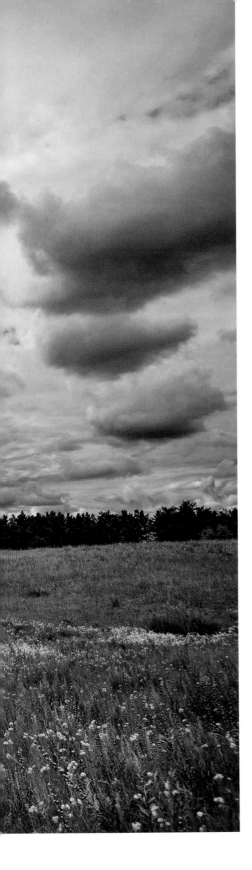

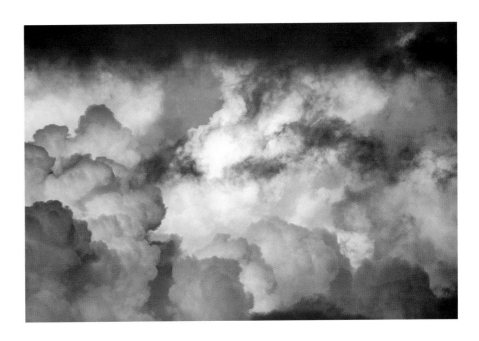

July 27, 2014

A loud clap of thunder awakens me. I glance at the clock—midnight. Looking out the cabin window I am treated to a light show that exceeds any Fourth of July display. Constant flashes of lightning tear across an angry sky, turning night into day. And then a downpour of much needed rain.

July 29, 1967

I saw a buck this afternoon; his horns were still in the velvet and his coat much redder than it will be this fall. He was relaxing in a small clump of pines and aspen where he enjoyed some reprieve from the hot sun and could enjoy the cool westerly breezes.

August 6, 2014

Sunny but dry. Need rain. Three-tenths of an inch fell two nights ago, but not nearly enough. Lawn grass crunches underfoot. The garden suffers.

I hike to the small patch of big bluestem grass that grows on a side hill adjacent to my prairie restoration project. It's about five feet tall and still growing. Tough. Resists the dry weather and returns every year, which it likely has done for hundreds of years, as I doubt this steep side hill was ever plowed.

The mid- to late-summer wildflower show is just beginning. I spot a few early goldenrods, their display of brilliant yellow contrasting with the green grass that surrounds them. The blazing star, with its stalk of bluish flowers, is just beginning to open, and I spot a few butterfly weeds, a beautiful orange flower with an unfortunate name, as I surely do not consider them a weed. They do indeed attract butterflies of every kind. I spot a small patch of butter and eggs, their name describing their appearance. And few black-eyed Susans remain in bloom. I also see a large patch of spotted knapweed, in full bloom with attractive blue flowers. They're considered by many to be a noxious nonnative plant, but I must say I rather enjoy their floral display every year. We're a few weeks away from the full wildflower display. A good rain will help.

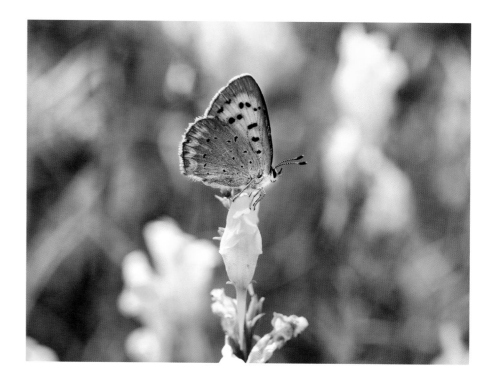

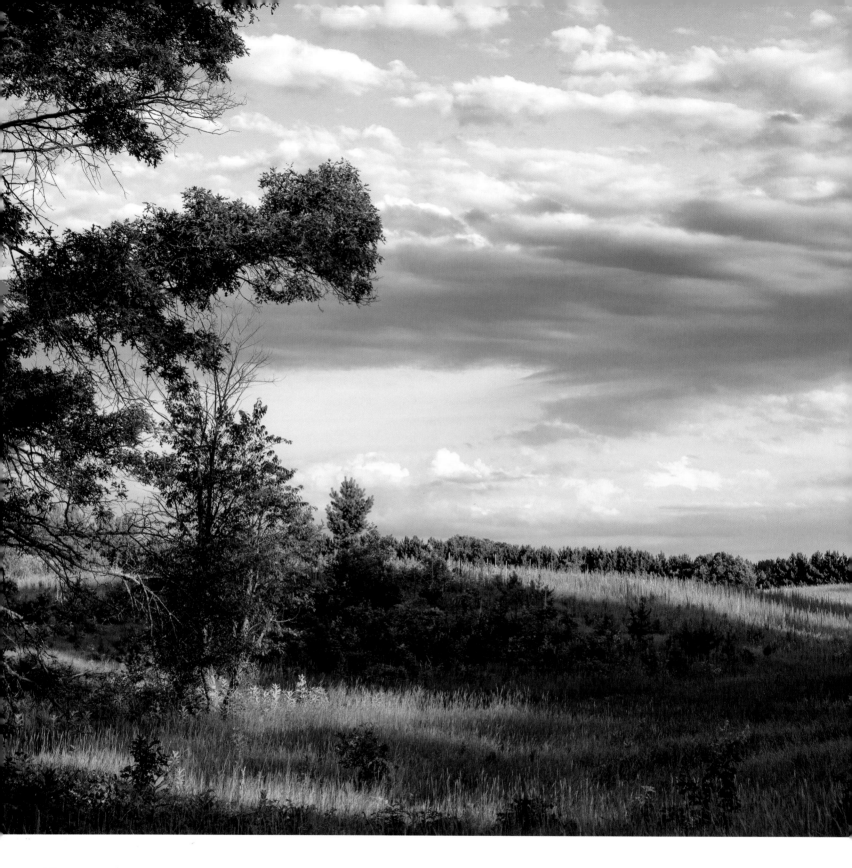

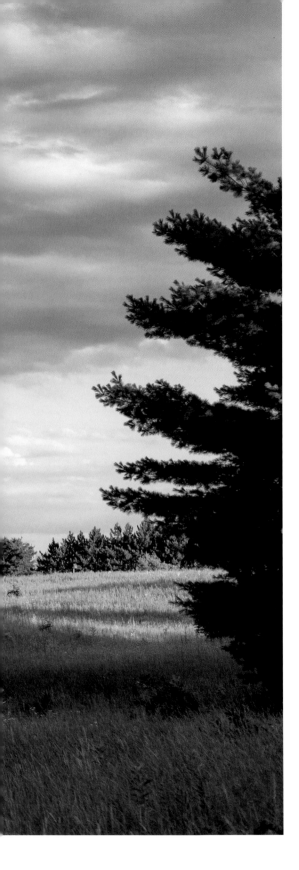

August 9, 1970

It's 8:30 p.m. and the sun has already slipped behind the trees west of the cabin. The coolness of the evening is filtering across the countryside. A cicada calls from the top of a willow tree in the near darkness of early evening. The crickets are playing their assorted tunes, rubbing their legs together quickly as the temperature remains in the seventies. The temperature reached the nineties today, and we so much need a good rain. The grass on the hillsides crackles and crunches as we walk on it.

August 16, 2014

I'm sitting at the edge of the old white pine windbreak, looking toward the west at the buildup of clouds. Weather forecast is for 50 percent chance of rain, but I don't see enough anger in these clouds for rain. They look too friendly, too much like "we are just passing by" clouds. It rained an inch last Monday, much needed as the garden was suffering.

Autumn

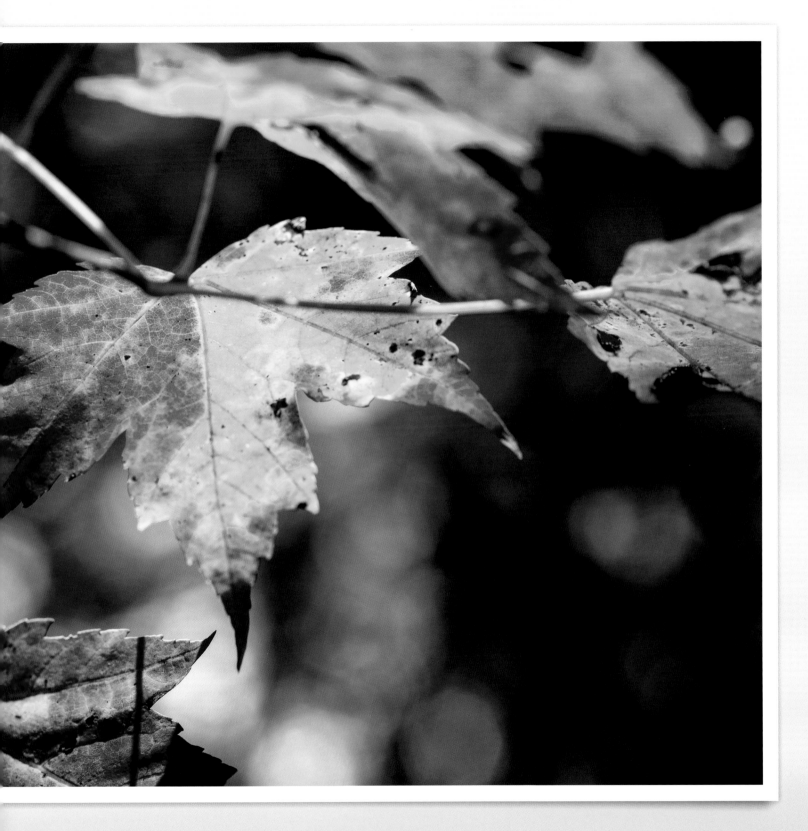

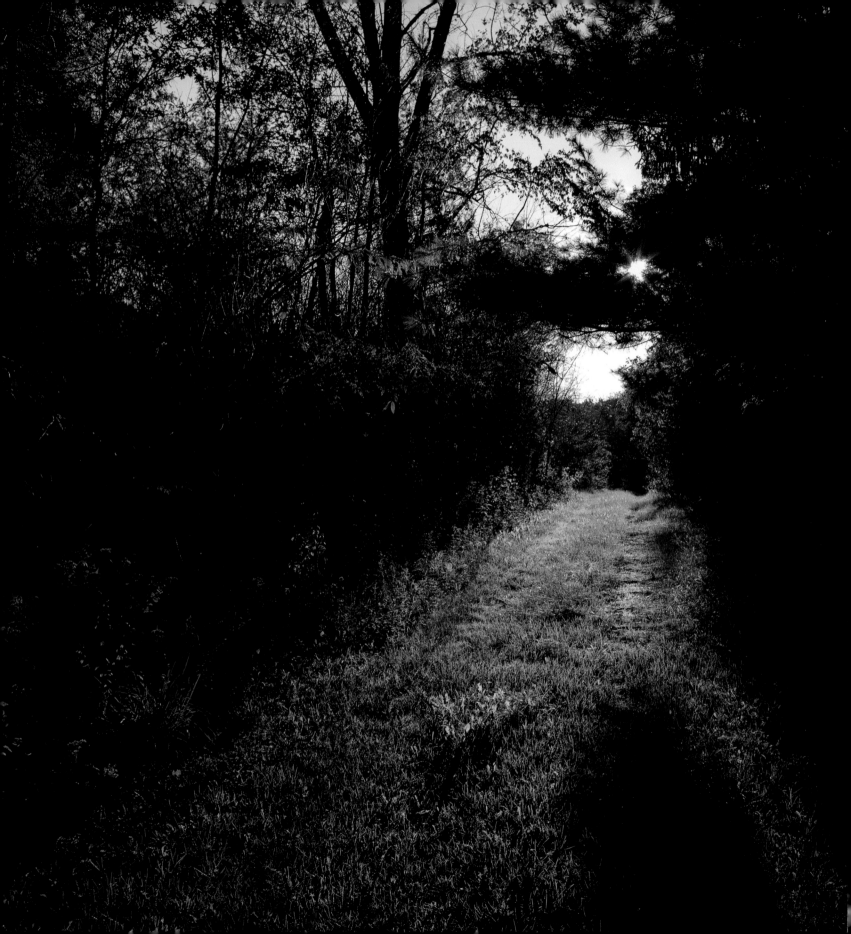

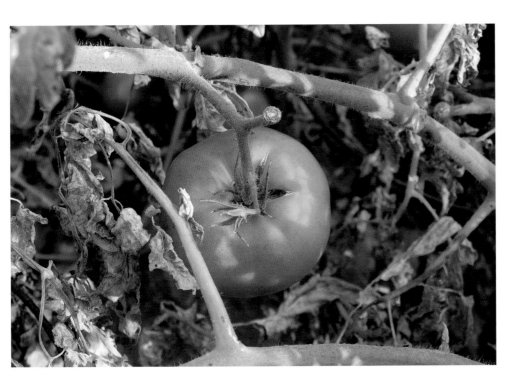

September 1, 2014

Four inches of rain in the last two weeks, much needed rain. The lawn grass is revived and needs mowing. Five deer greeted us when we arrived here on Friday evening, big ones and little ones, all munching on the new grass in our lawn. They bounded away, I suspect not at all happy to have their supper disturbed. What a difference the rains make—the countryside is once more green and growing, the squash and the pumpkins are happy, the zucchini is flourishing, the tomatoes are outdoing themselves.

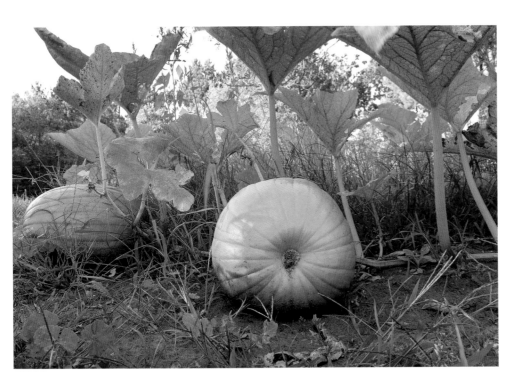

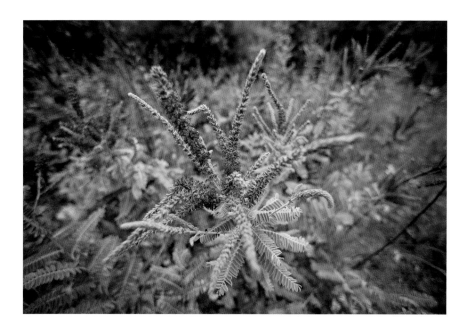

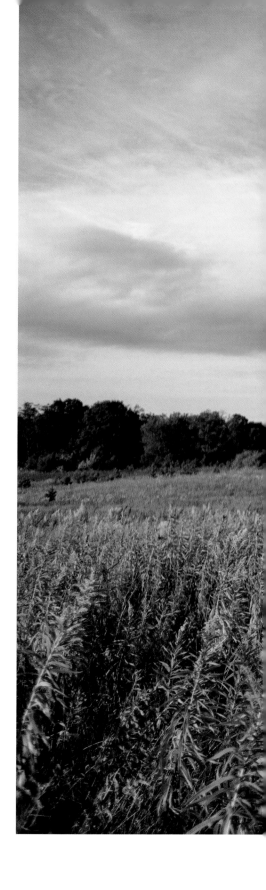

September 5, 2014

Several clumps of leadplant grow in the prairie at Roshara, a most interesting plant. The early pioneers found the fifteen-foot and longer roots a challenge for their breaking plows and dubbed it "the devil's shoestring." A kinder name for this plant that lives hundreds of years is "prairie shoestring," because it is often found on tall grass prairies along with big bluestem and little bluestem grasses.

The plant grows but a few feet tall, with a purplish flower that blooms in early to late summer, and as it grows older it takes on the appearance of a small shrub. The whitish to grayish leaves often appear dusted with white lead—thus the common name for the plant.

September 7, 2014

In the last couple of weeks, my prairie has turned from green to yellow and blue as the sea of goldenrods are in their glory and the blazing star flowers add a subtle blue as counterpoint to the yellow. It is a sight to behold—a spiritual harvest of color.

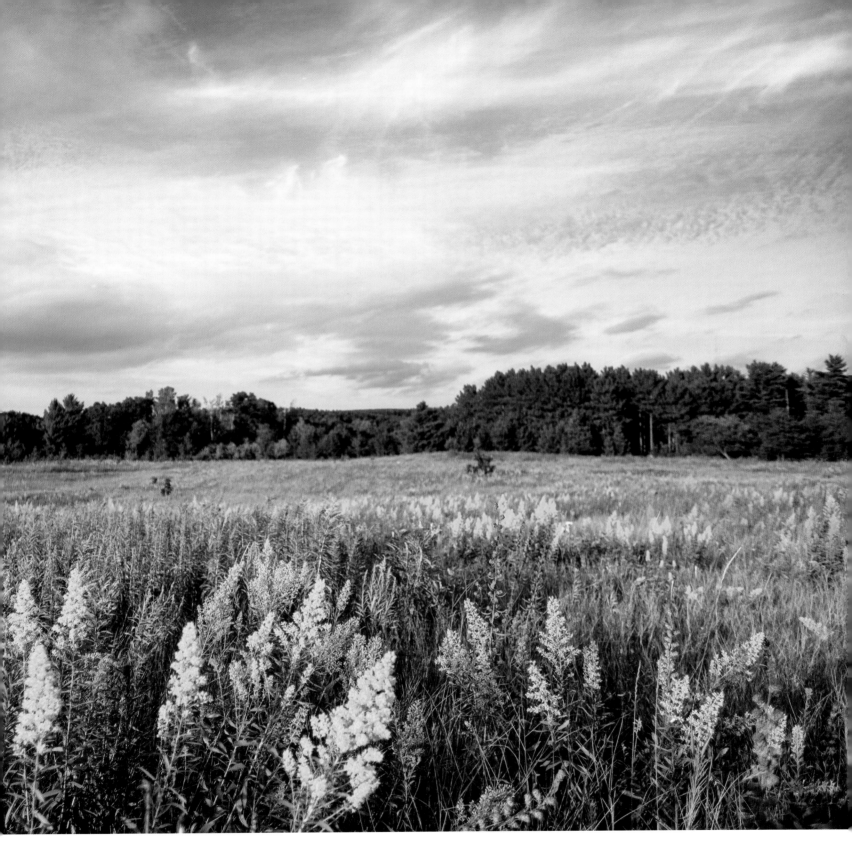

September 7, 1992

What a treat Ruth and I had last night as we took a long walk after supper to the field west of the red pine plantation. We spotted a doe grazing under a black cherry tree and soon saw her two fawns, which are about half grown. They are so curious. They nearly walked up to us as we stood motionless, their long ears flicking back and forth. We had at least a five-minute show before they snorted loudly and bounded off. What fun.

September 18, 2014

The plants, the animals, all of nature seem to be waiting. Waiting for the first killing frost to signal the shift from summer to autumn, no matter what the calendar says. So far this month the temperature has dipped to the mid-thirties, but nothing below that. The wildflowers have mostly finished blooming; a few rather dull yellow goldenrods remain, but nothing like the explosion of color a few weeks ago. Here and there a maple shows a little red and a birch a little yellow. But mostly everything appears on hold—waiting for that first frost, which will come any day now.

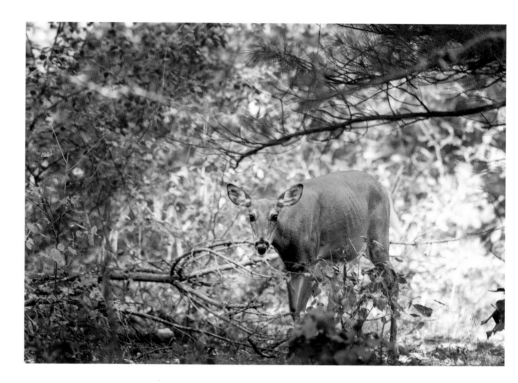

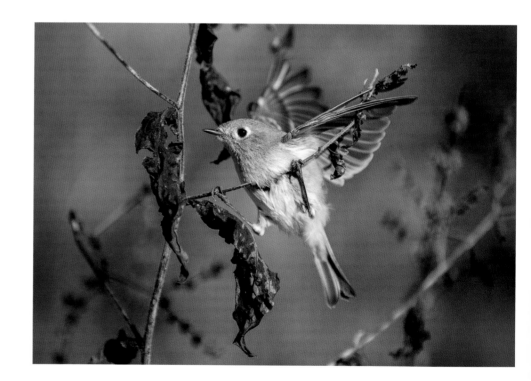

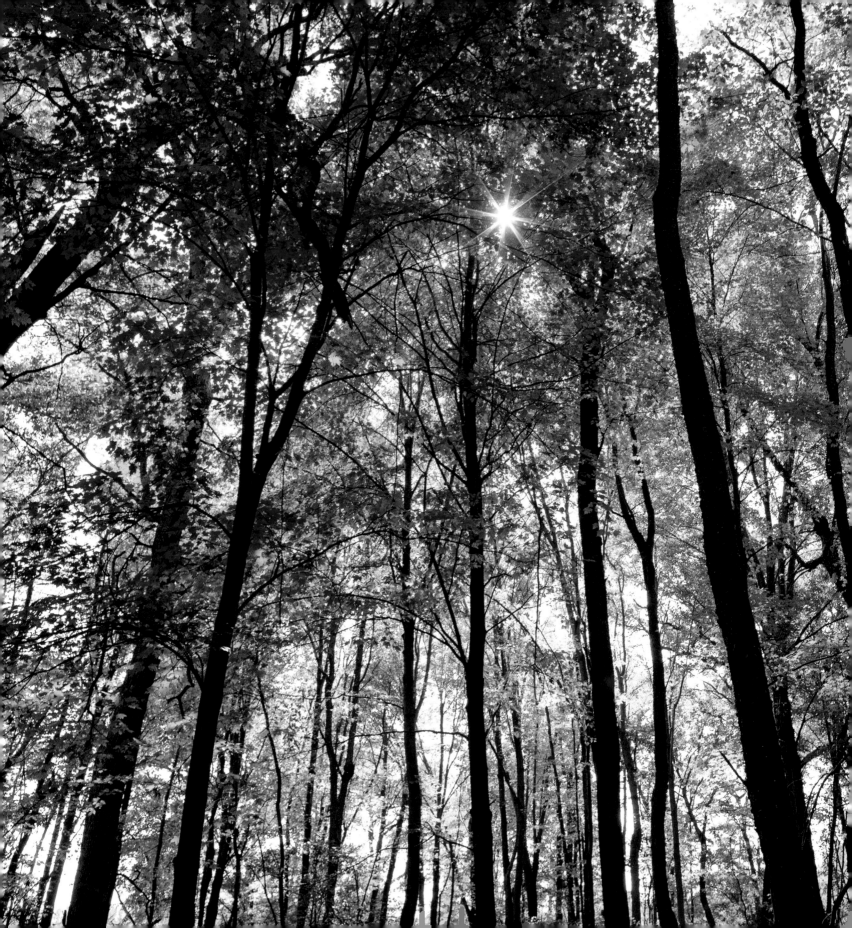

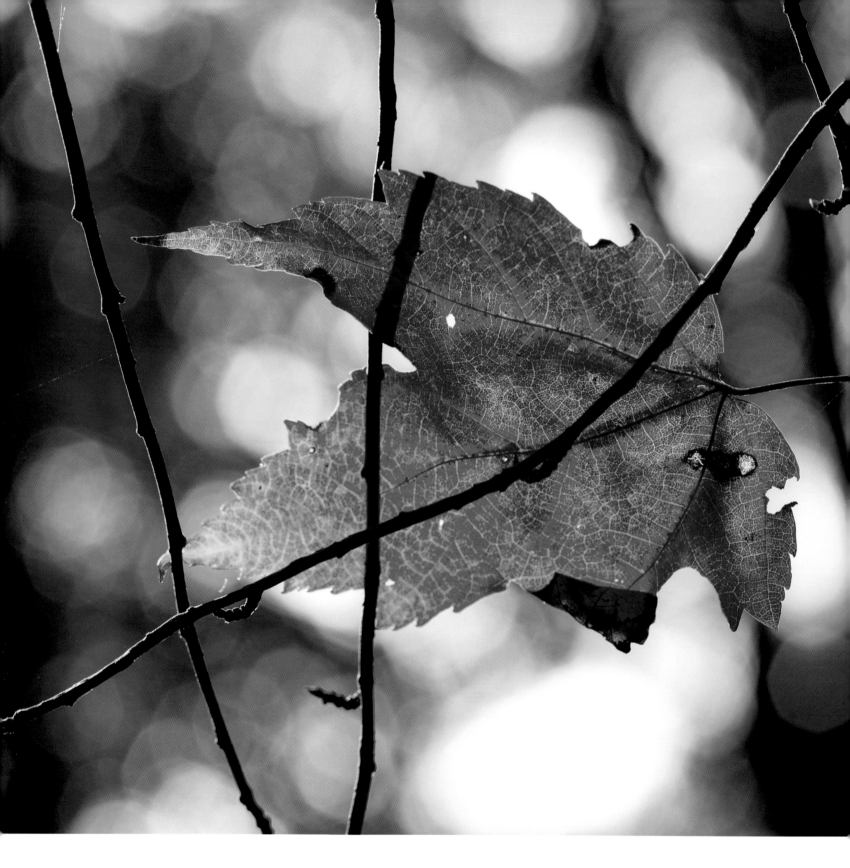

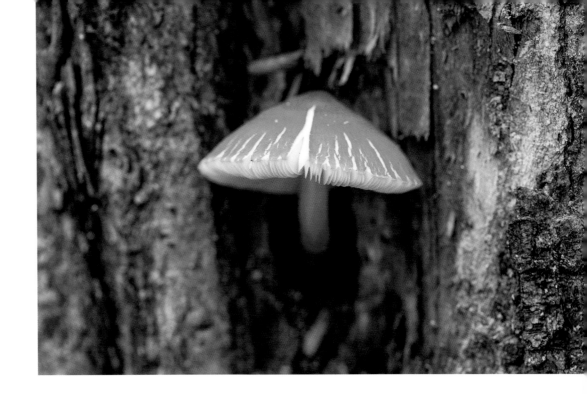

September 19, 2014

I don't know why, but today I am thinking about "curved" and "straight." It occurred to me that much of the natural world consists of curved lines. That's probably because the planet itself is curved, a sphere. I thought about plants and how many of them appear to have straight lines when in reality they don't. Exceptions are the octagonal configurations within seeds. But even the octagon is within a structure made up of curved lines. Snowflakes, apparently formed in straight lines, form curved lines when they accumulate on the landscape. Perhaps lake ice is an exception. When a lake freezes, its surface appears flat and straight. But to fit the curved surface of the earth, even the lake ice must have an ever so slight curve in it.

My question is why we humans spend so much time thinking and doing "straight." Straight roads, homes built with straight lines, straight thinking—starting at one point, moving to the next point, and so on rather than beginning in the middle of a thought and then allowing our thinking to radiate out from it like a spider web. We applaud straight; curves often confuse us. Just thinking about these things today. No great purpose in mind.

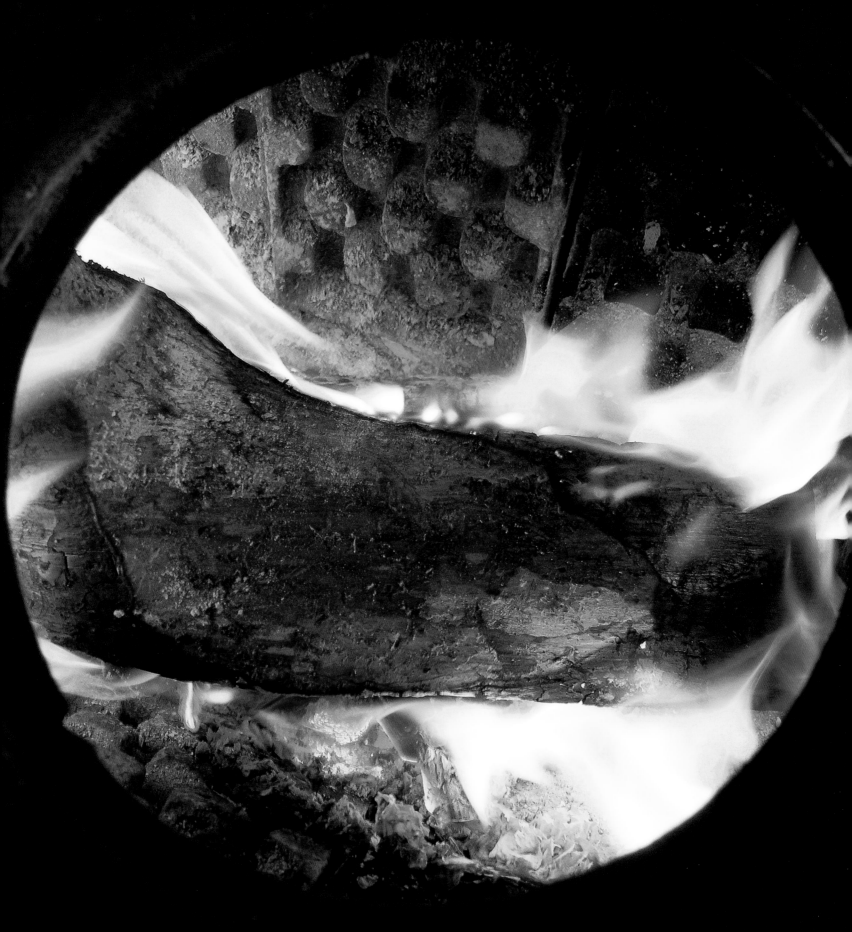

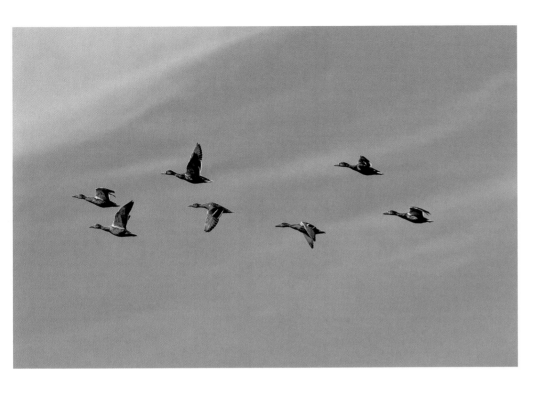

September 19, 1970

Ruth and I walked around Roshara this morning. At the pond we saw a place on the west bank that was torn up and the soil disturbed. We wondered if a bear did it. Last week our neighbors a half mile north, the Robert Turners, had a big black bear stare in their living room window when they were watching television. So it's possible a bear has been rooting around by our pond. A new excitement at Roshara.

Our wood-burning stove is hooked up now, and what a fine addition it makes to our cabin. A few sticks of kindling wood, a crumpled-up newspaper, and soon a warm glow comes from the top of the stove. How nice it is, the sound of crackling pinewood consumed by the flames and the sweet smell of pine smoke sneaking from around the stove's lids, just a hint, but enough to remind me of when I was growing up and we heated our drafty farmhouse with woodstoves.

September 23, 1967

I went bow hunting this afternoon and saw two of the biggest bucks I've ever seen. They came out of the woods to drink at the pond, but they soon spotted me and would not come within range of my bow. They stood their ground for at least ten minutes—it seemed like ten minutes, anyway.

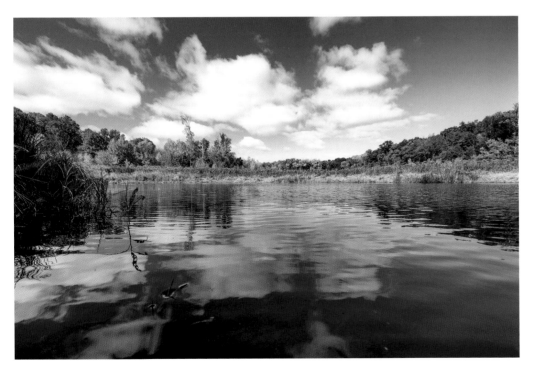

September 27, 2014

I'm standing at my pond, looking to the west where the maples are beginning to show their colors, deep reds and striking yellows. A little bit ago twelve ducks lifted from the pond, circled once, and flew off, to return when I'm not here. Not a breath of air stirs on this warm autumn afternoon with the temperature in the seventies. The nights are cool and the days warm—how much longer will this weather continue? I'm enjoying it while it's here, soaking up the smells of fallen leaves, watching the clear blue pond water sprinkled here and there with pond lilies, and appreciating life.

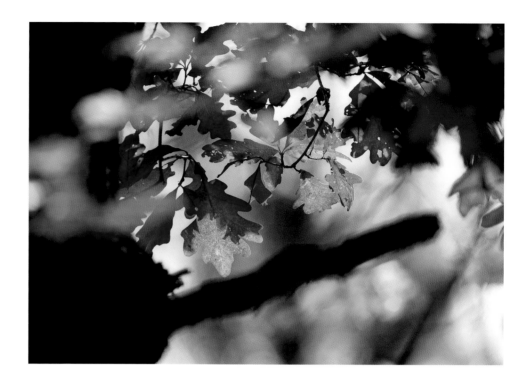

October 6, 1979

How quiet it is at the farm compared to the city, where we accept a constant background noise. At Roshara the polluting noise is absent. It is possible to hear a crow call in the woods a half-mile away, and at night the quiet is nearly overwhelming, especially on this cool, crisp fall evening. It's possible to hear your own breathing.

I will be back at my desk on Monday, both tired and rested. I've discovered some new muscles in my arms from splitting wood. But my mind is rested. My sense of who I am is once more affirmed. Living close to the land, if only for a brief time, does that for me.

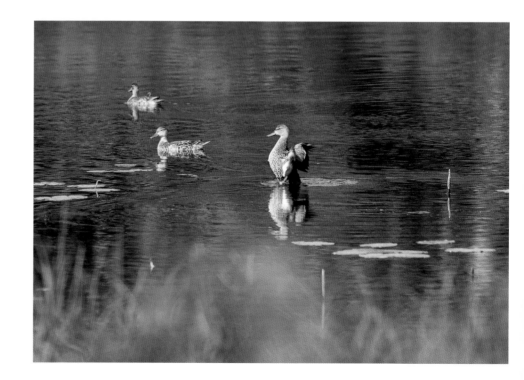

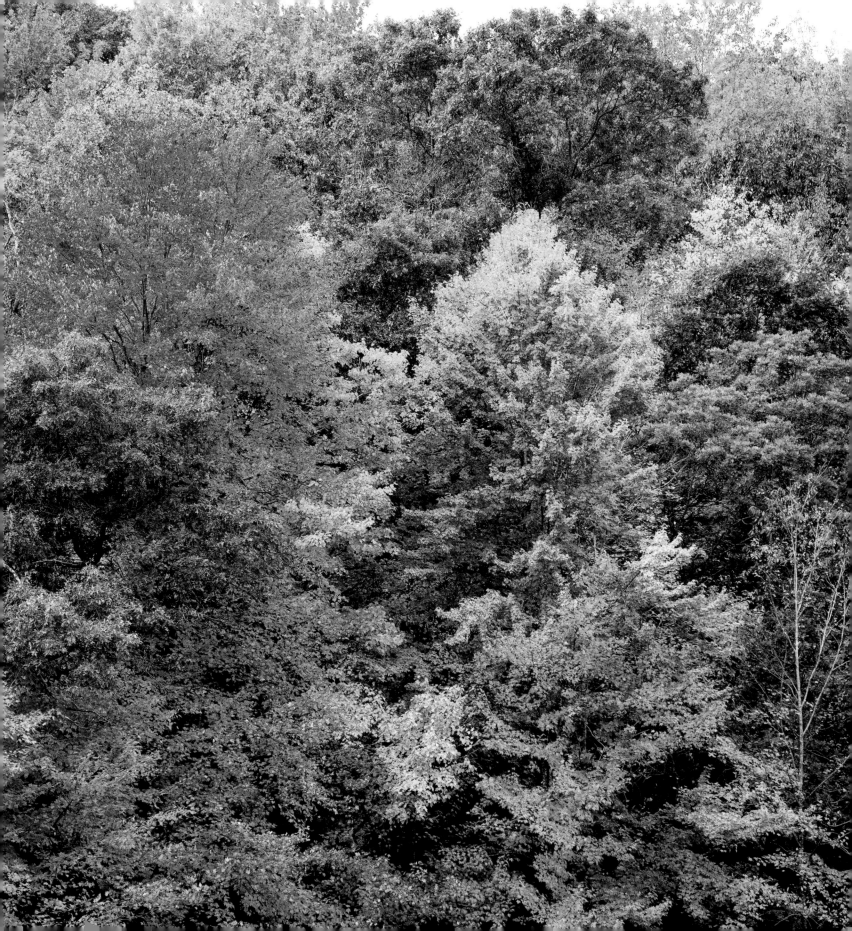

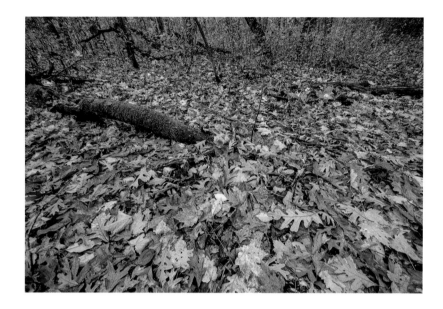

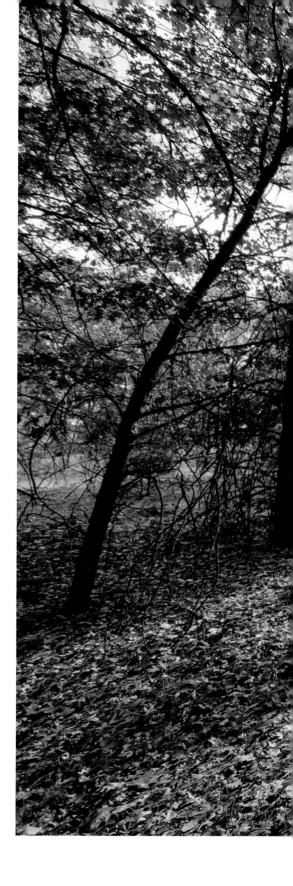

October 11, 2014

Frost covers everything—the lawn, the woodshed roof, and the cabin roof—as I start my predawn hike. It is quiet, so quiet in the woods north of the cabin. No sound except for the crunch of fallen leaves as I slowly move along, listening, looking. The oaks are about one-third full color, the maples are at peak or maybe a little past—and I am smelling the wonderful aroma of fall, so different from the smells of the other seasons. Pungent, earthy smells recording the handoff of fall to winter.

As I hike back toward the cabin, the sun begins to peek above my neighbor's pine plantation to the east, and soon I see the first rays of sunlight reflecting off the top of the big maple tree in front of the cabin. This tree, a gift from my children on my sixtieth birthday, is showing russet red from top to bottom.

Spears of green winter wheat contrast with the white frost in the garden spot—now tucked in for the winter with its green cover.

Once back in the cabin, I start the woodstove for the first time this fall. I sit at my kitchen table with a strong cup of coffee. It will be a good day.

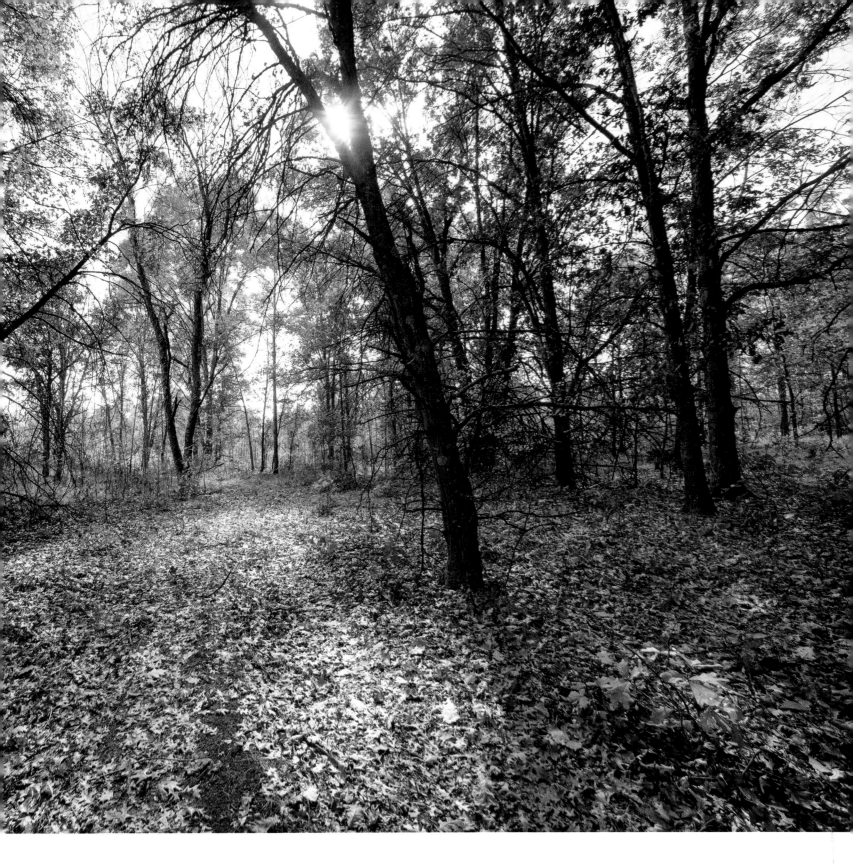

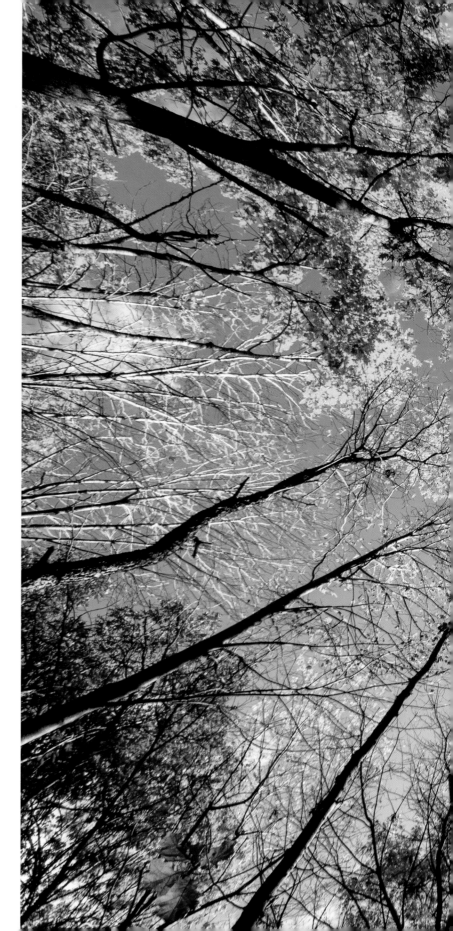

October 13, 1981

I cut up a birch tree and a black cherry tree that were victims of a recent windstorm. I also found a white pine that had succumbed to blister rust and sawed it into blocks. We have enough firewood for another winter season.

On Sunday, when it was sunny and clear, I hiked around the farm. The aspen are in full color, as are the maples—yellow and red contrasting with the clear blue sky. Nine Canada geese landed on the pond, and I spent a long while sneaking through the brush so I could see them up close. They finally saw me and flew off with loud honking—no doubt "honked off" that I had disturbed their rest.

October 15, 1979

Jeff and I sold produce at the farmers market in Madison on Saturday morning: rainbow corn, 3 ears for 25 cents; popcorn, 5 cents an ear; squash, 25 cents, 15 cents, 10 cents depending on the size. We took in $17.50, which wasn't bad considering it was a cold, windy morning on Madison's Capitol Square. The temperature was in the thirties. I gave Jeff half of the money for helping me— and he was quite pleased.

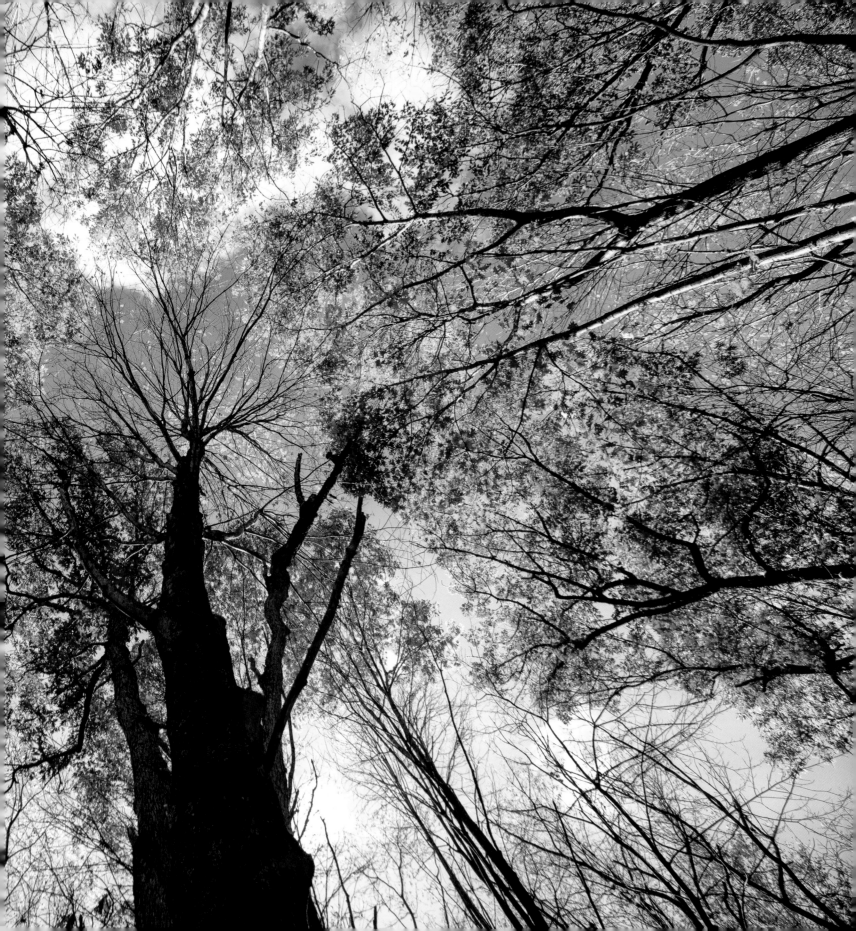

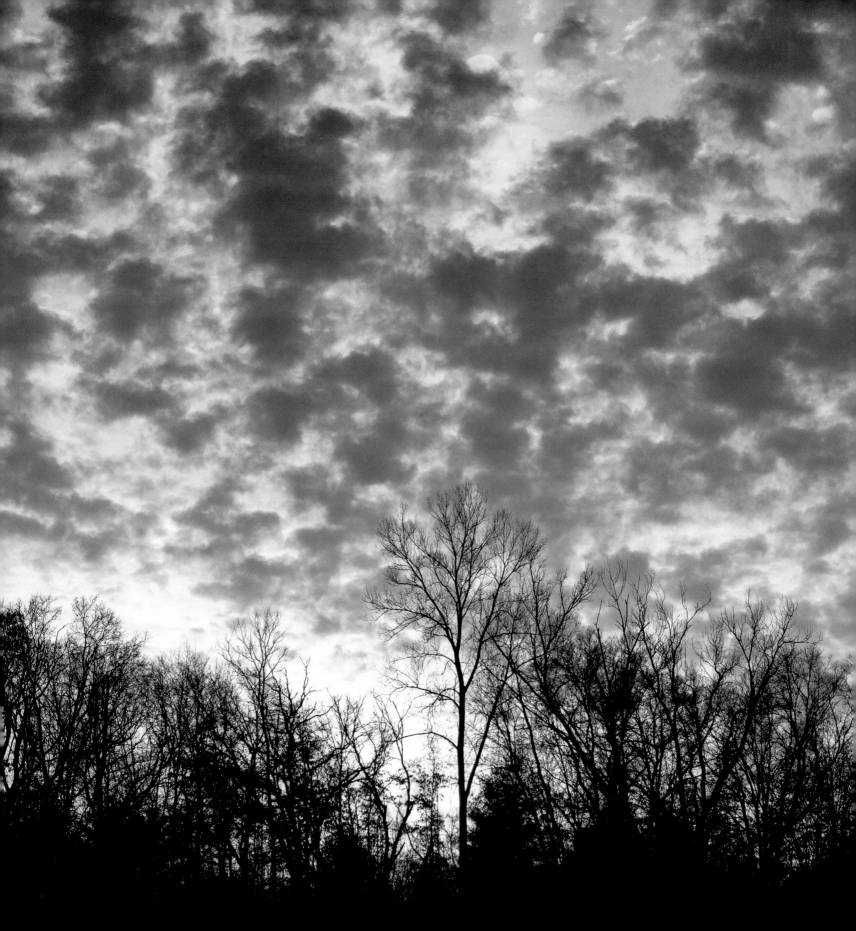

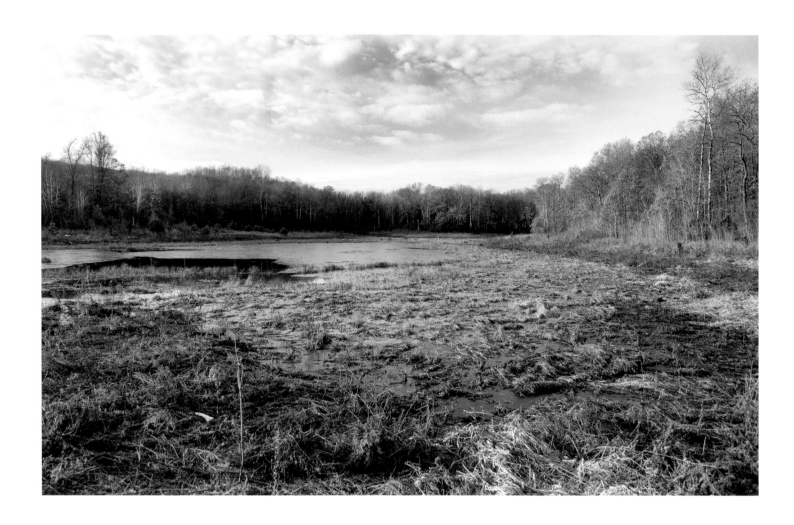

October 17, 2014

First sunny day after three days of rain. More than two inches—always welcome. I walked to Pond One this afternoon, temperature 60 degrees, sky so clear and blue, and the trees, especially the oaks and the aspen, showing spectacular fall color. Nature knows how to celebrate fall as we wait for snow and the winter winds to once more come visiting from the north.

October 26, 2014

Last week brilliant fall colors. Today, as I sit by my pond, the maple trees are bare, the aspens are nearly naked, and the oaks—those that still have leaves—now show the dull brown of late fall.

The pond's black water contrasts with the dead grasses, victims of several killing frosts this week. A cluster of birch trees stand a few yards in front of me; their striking white bark stands out against the tans and browns of fall.

The smells of fall surround me, not at all unpleasant as I sit quietly listening to the sound of the northwest wind moving through the tops of the naked trees. Winter is many days away, but the symbols and sounds are here—preparing us, I suspect, for what is to come.

November 8, 2014

Temperature in the high thirties. Cloudy. The black willow windbreak is a tangle of bare limbs twisted and torn from the winds of many years. These more-than hundred-year-old trees stand ready for yet another winter. All is quiet at Roshara, save for the cold wind moving through the bare willow branches, singing a melancholy song.

November 15, 1970

On Saturday the three kids and I tramped the fields until nearly dark. They love running over the land, searching for whatever there is to find, rolling down the steep hills, exploring around the pond. Running, jumping, laughing. Being kids. Being with the land.

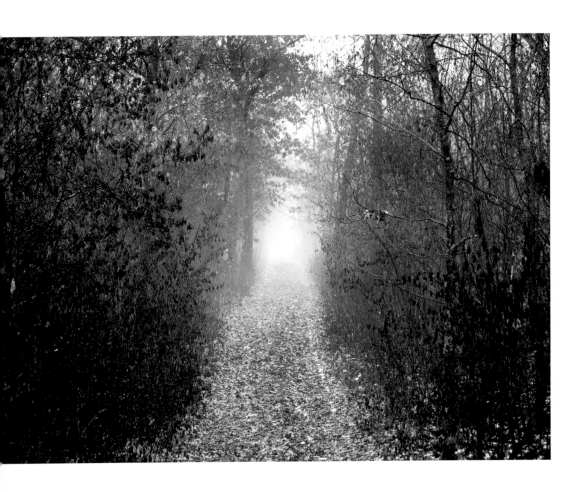

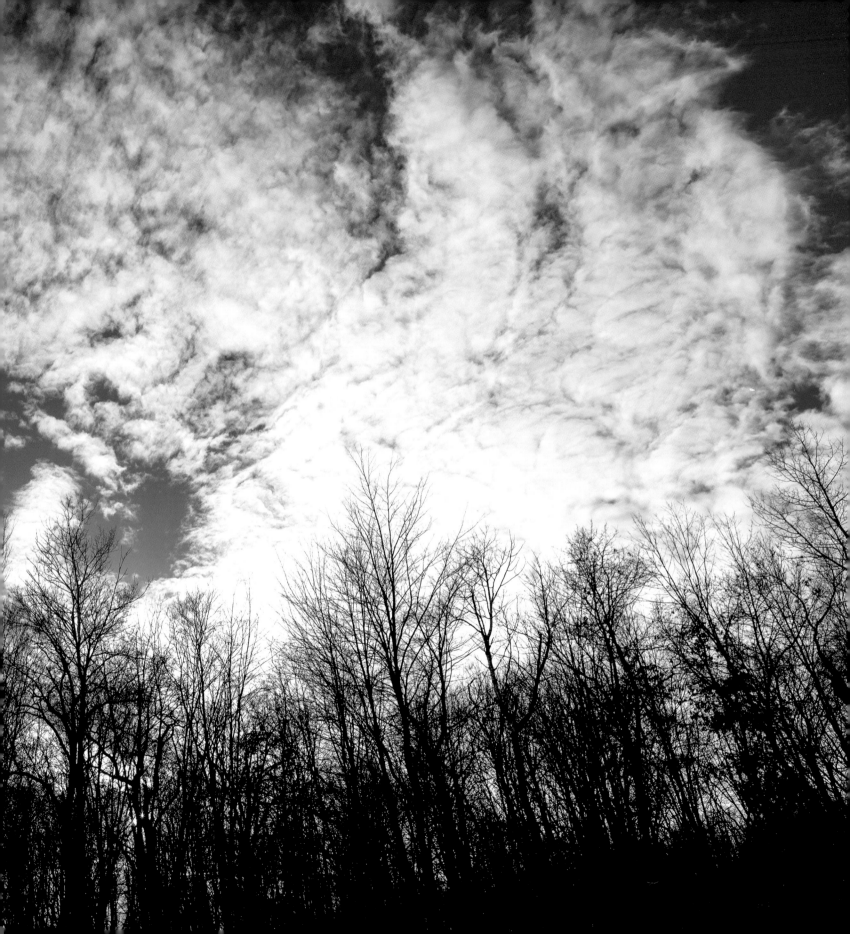

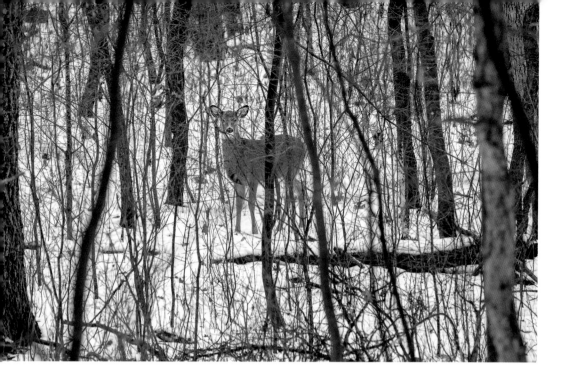

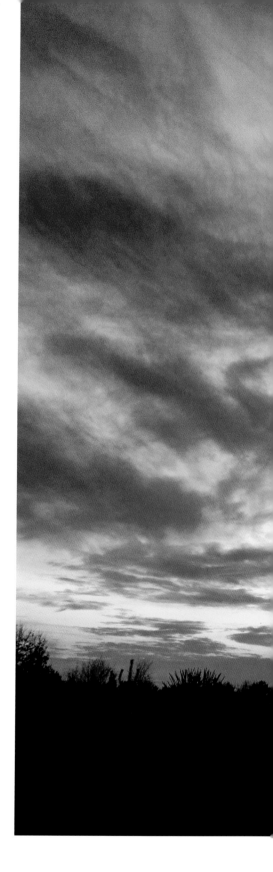

November 19, 1967

Deer hunting with dad and brother Donald. This is my twenty-first year. Saw one deer this morning and three this afternoon. All too far away so I couldn't tell bucks from does. Driving back to Madison in the evening, I saw where two cars had tangled with deer—both cars were in the ditch. Upon arriving in Madison, Steve helped me unload the car. He told me, "I'm going to be a big hunter when I grow up." He is now five years old.

November 19, 1984

Last Saturday was opening day of deer season. My thirty-eighth year. I hunted with Steve and my dad. Steve shot a nice buck before noon. He's a good hunter and an accurate shooter. Venison on the table this winter.

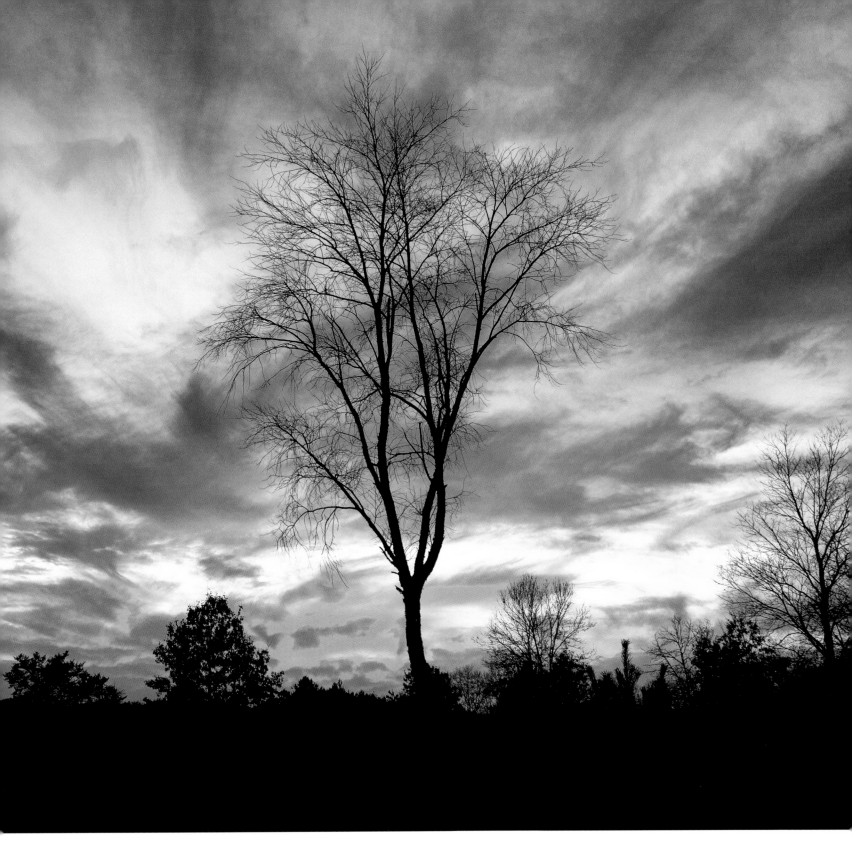

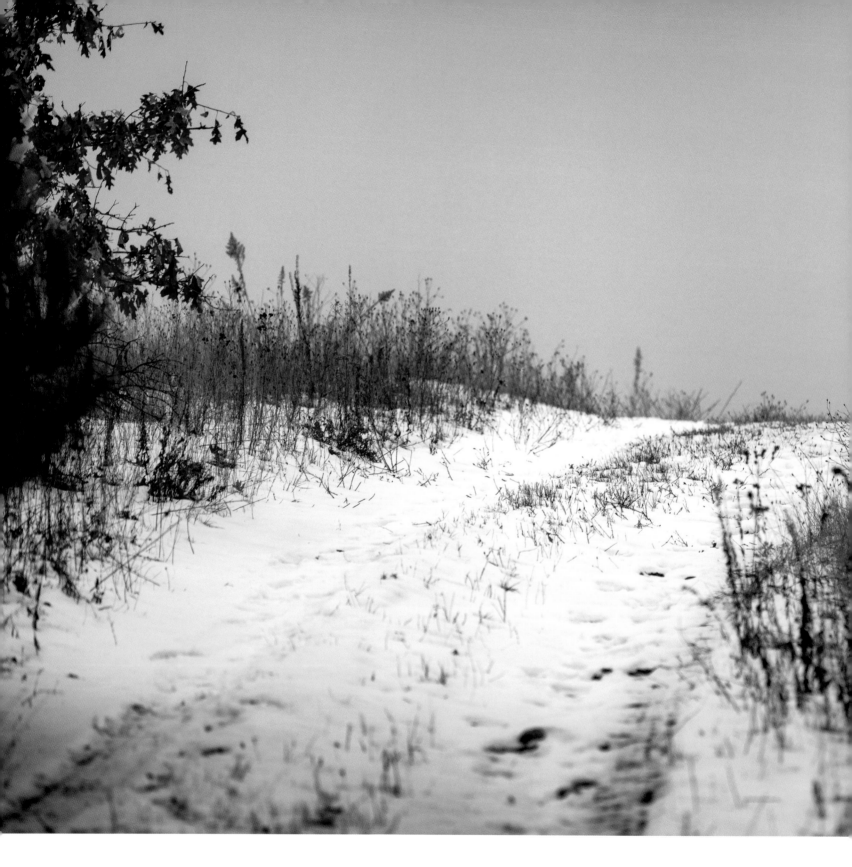

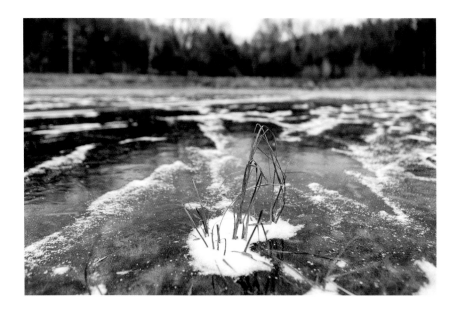

November 21, 2014

Nine below zero this morning. About three inches of snow on the ground. Old Man Winter is here with a vengeance and a month early. Does this mean an early spring? Or is this morning a wicked reminder that ready or not winter is here and probably here to stay for a while? I walked to my pond this morning—it's frozen solid—and not a creature is stirring, except for a lone crow I spot flying overhead. I am sitting by my wood-burning stove this afternoon. Nice.

November 22, 2014

Opening day of deer gun season. My sixty-ninth year, without missing a year, even made it when I was in the army. I sat where my father sat the last year he hunted deer. It was 1992 and he was ninety-two. As I sat and waited and looked and listened, I could still hear my father's words: "You've got to be patient, and you've got to be quiet."

Although my dad didn't talk about it, deer hunting for him, as it is for me, is about much more than the hunt. It is about tradition and it is about family. In addition to my son and me, this year's hunting crew included my brother and his three sons. For us deer hunting is a time for storytelling and good food and being outdoors on a chilly November morning and enjoying the sights and sounds. It is also a time for remembering, as I sat where my father sat twenty-two years ago, he with his 30-30 Savage rifle on his lap, me with my 30-30 Winchester rifle on my lap. He would be pleased to know that his sons and grandsons are carrying on the tradition.

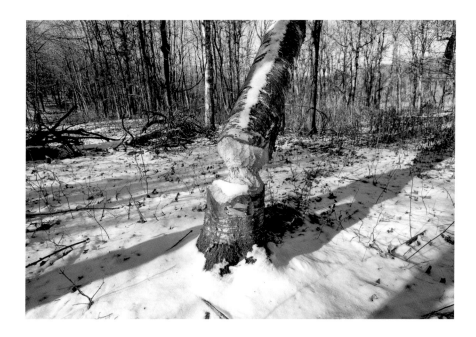

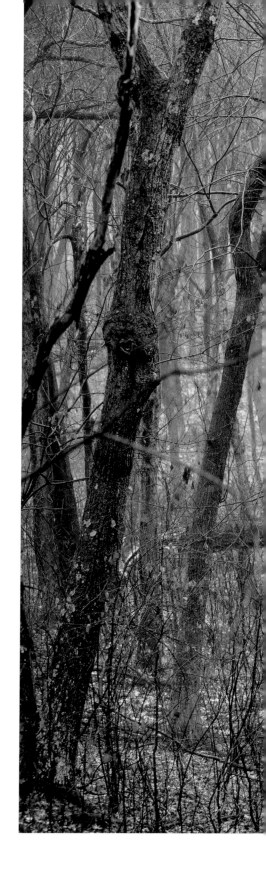

November 26, 1970

Wind gusts to fifty miles per hour, tearing thousands of small branches loose from the willow windbreak and scattering them across the cabin's lawn. We'll have some cleaning up to do before we can run the lawnmower on the lawn next spring. I wonder how many branches and dead trees are down in the woodlot.

December 4, 1971

We have a new painting of our cabin at Roshara. Bill Boose, a professional artist who lives a few miles east of Wild Rose, painted it for me, and he did a great job. Bill drove out to the farm this fall, set up his easel in the field in front of the cabin for several afternoons, and did the work. He captured the wildflowers and weeds just as they are, and the old wire fence in such detail that I can count the barbs on the wire, and of course the cabin itself. When he finished I was almost afraid to ask him what he wanted for the work. I said I would take care of the framing, but he said, "I want to frame it myself, so it's done right." We looked at each other, me expecting some figure beyond my means. Finally he said, "How about seventy-five dollars?" It is Ruth's and my Christmas present to each other.

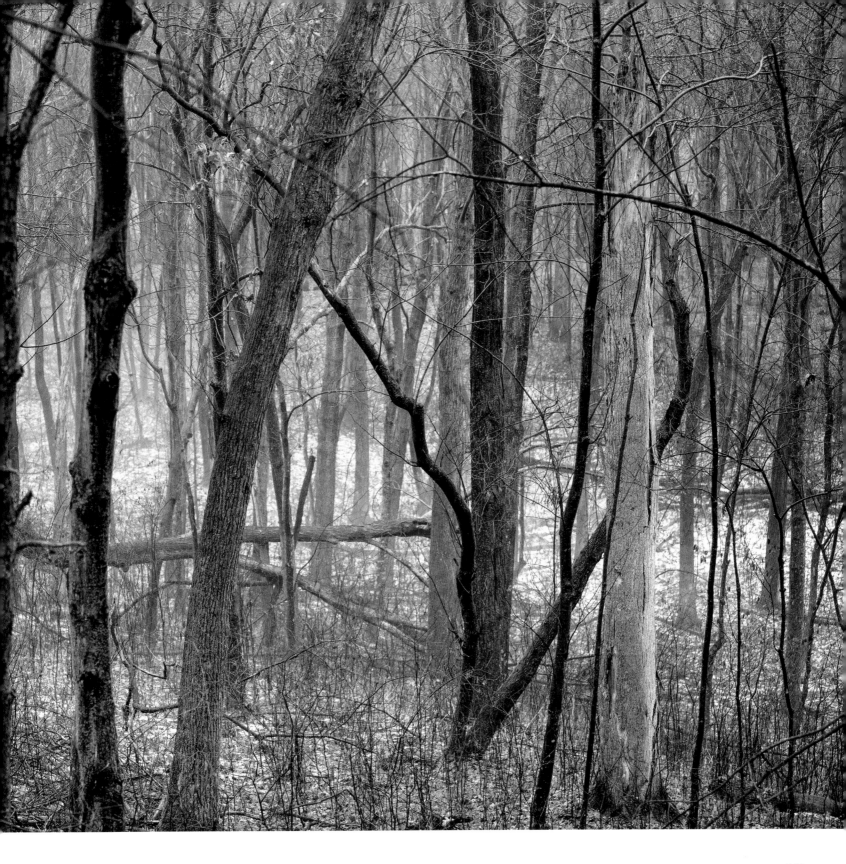

December 8, 1968

The pond is frozen now, just right for skating. I am there with the kids, looking at the deer tracks in the fresh snow, as well signs of raccoon, fox, and even a field mouse's trail. We saw where the fox had looked for the mouse—an interesting nature lesson for the kids. It's cold, about 10 degrees with a brisk wind from the north, so we didn't stay long.

The kids and I fastened corn to spikes I had driven through a board creating a squirrel feeder that we placed under one of the willow trees near the cabin, a tree where the kids have a swing. We also put some corn and oats in a crook of that same tree— a few extra treats for the wild critters.

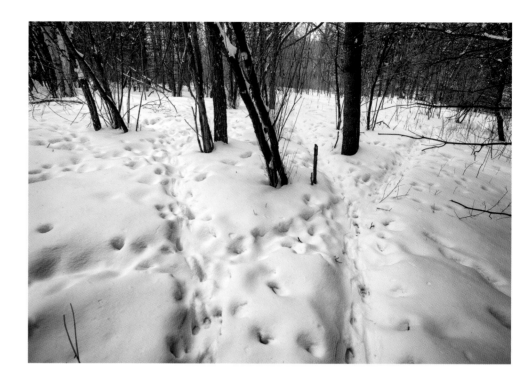

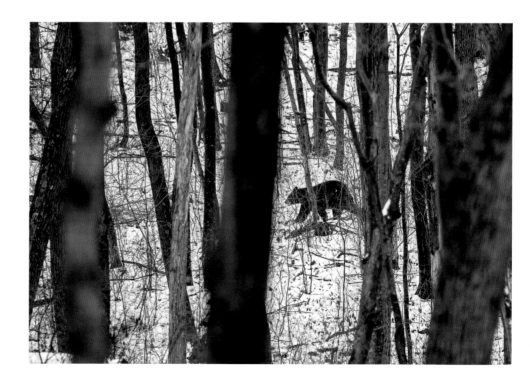

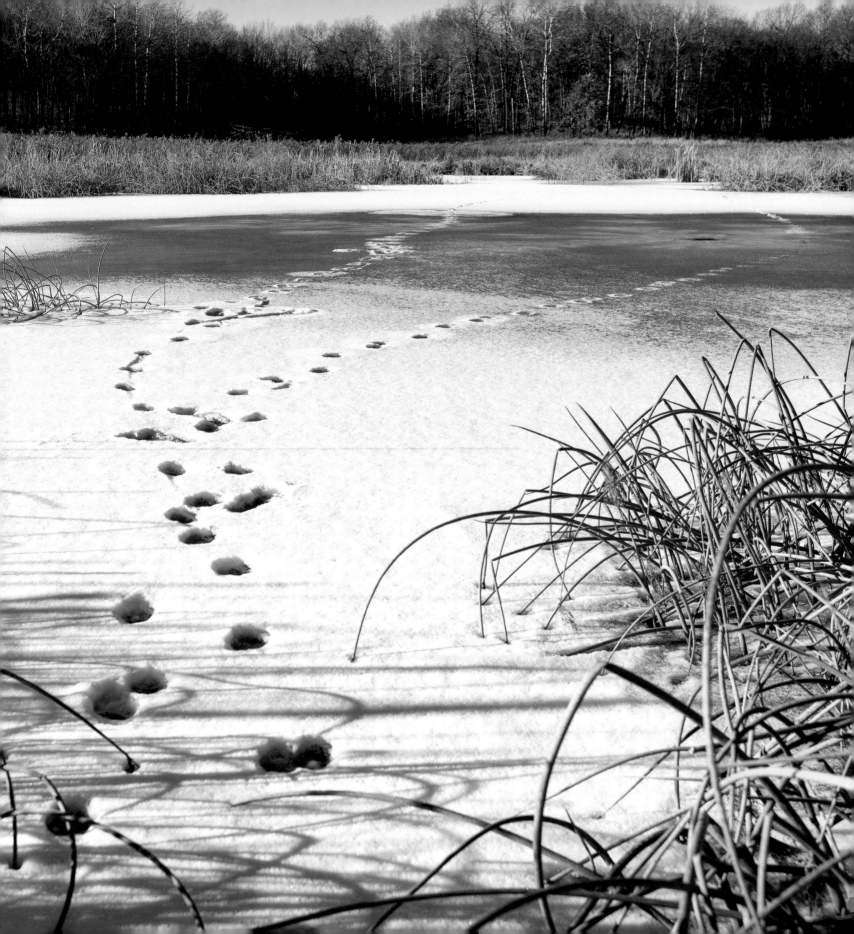

Winter

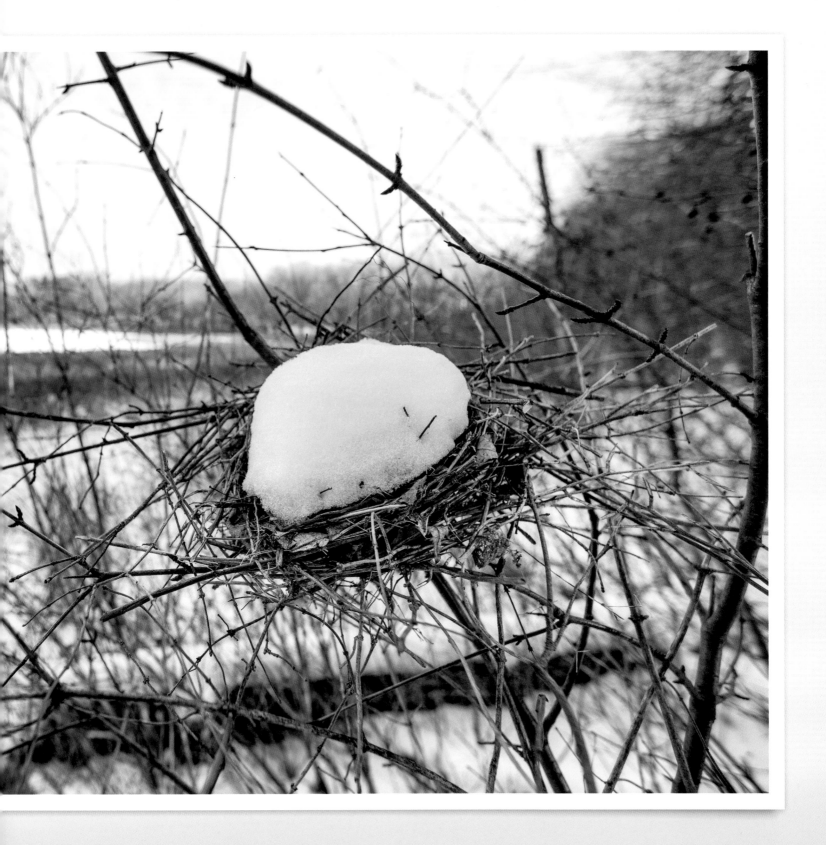

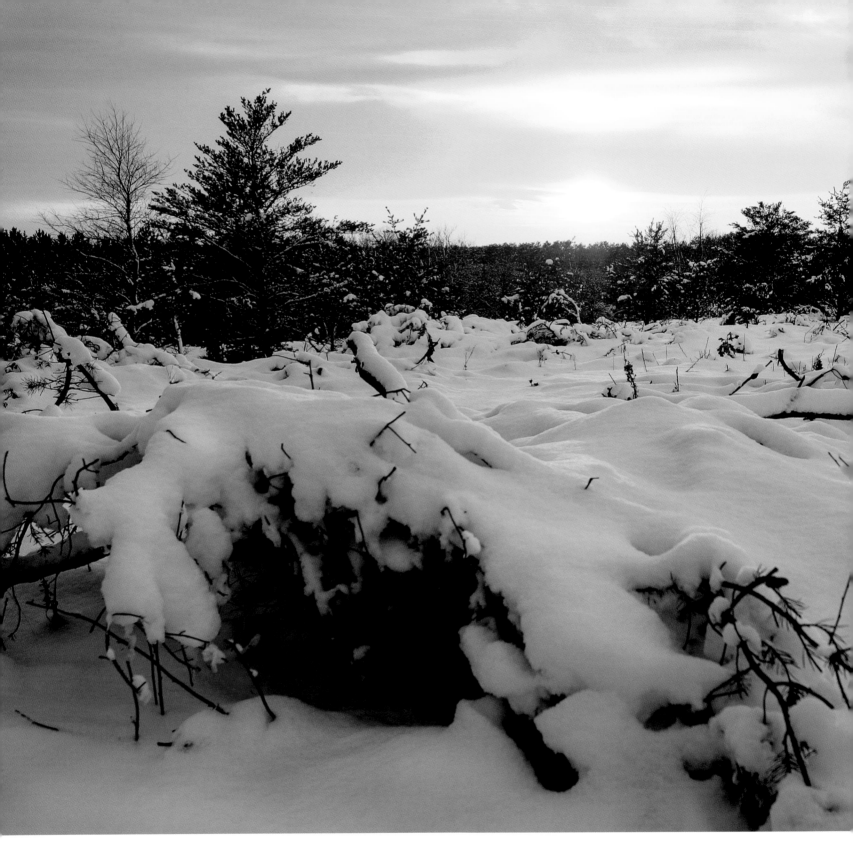

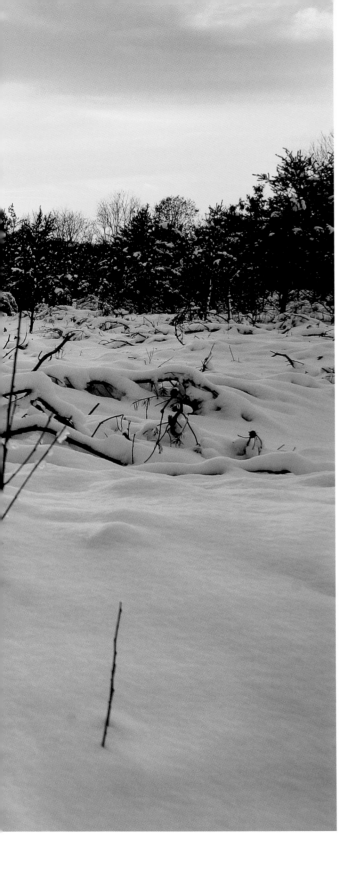

January 3, 2014

A couple feet of snow covers Roshara as we start the new year. A week ago the temperature soared to 40 degrees after more than a month of below-freezing weather. But now it's back to well below freezing. More like winter.

I'm sitting at the homemade table in my cabin, the woodstove at my back keeping me comfortable as I occasionally glance at the thermometer and see the outside temperature dropping. The late afternoon winter sun struggles desperately to warm the countryside but mostly fails as the temperature plummets at sunset. Down to zero degrees and still falling at five p.m. Even though the days are a smidgen longer since we are now more than a week past the winter solstice, darkness still comes by 4:30.

In the twilight I spot a deer, a big doe, walking down the trail that leads to our garden spot. The snow is to her knees, but she appears to have little difficulty moving along, looking for something to eat as the snow has buried all the grass, including the winter rye that I planted in my garden last October and that stays green all winter. The doe nibbles at the buds on the shrubs and small oak trees. I watch her. She is like a person at a cafeteria, picking something here, something there. Hoping to find enough to eat so she can sleep with a full belly on this cold, cold winter night.

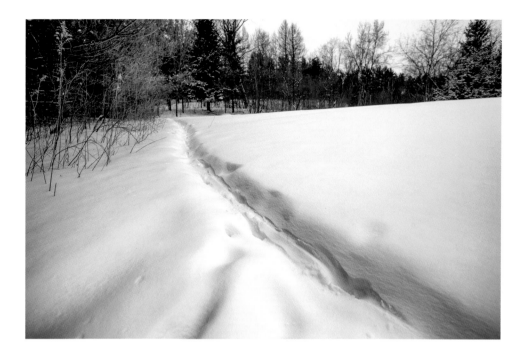

January 3, 1989

Quiet at Roshara. Beautiful. Yesterday the temperature rose to only 14 degrees, but the woodstove kept the cabin warm and comfortable, with only the minimum amount of wood. In the living room stove, I dare put in only one small stick of oak at a time or it quickly gets too warm in the cabin. I recall a few years ago when it was ten below zero and I put too much wood in the stove. Soon it was in the eighties in the cabin—with all the windows open.

Minus four degrees this morning. Clear. Snow squeaks when I walk to the woodshed for more stove wood. I've been cross-country skiing twice a day, once in the morning and once again in the afternoon. But crusty snow makes it too fast, too dangerous. I slid into a white pine tree this morning, cracking off several small branches. No damage to me, only to the tree.

January 4, 1987

Steve and I, my dad, and ninety-year-old John Swendrzynski went ice fishing last Friday and Saturday, at Mt. Morris Lake, a few miles from Roshara. Steve and John each caught northern pike on Friday; I caught one on Saturday and Dad caught two. The "catching" was average, but the "fishing" was outstanding, with lots of storytelling. The temperature was in the thirties with bright sunshine.

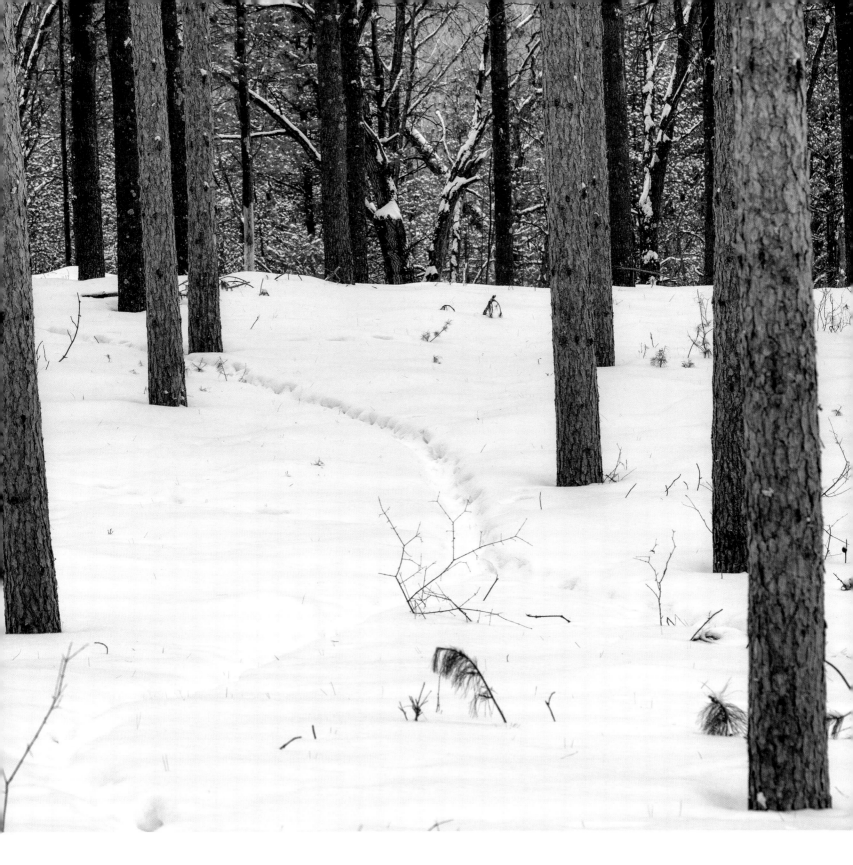

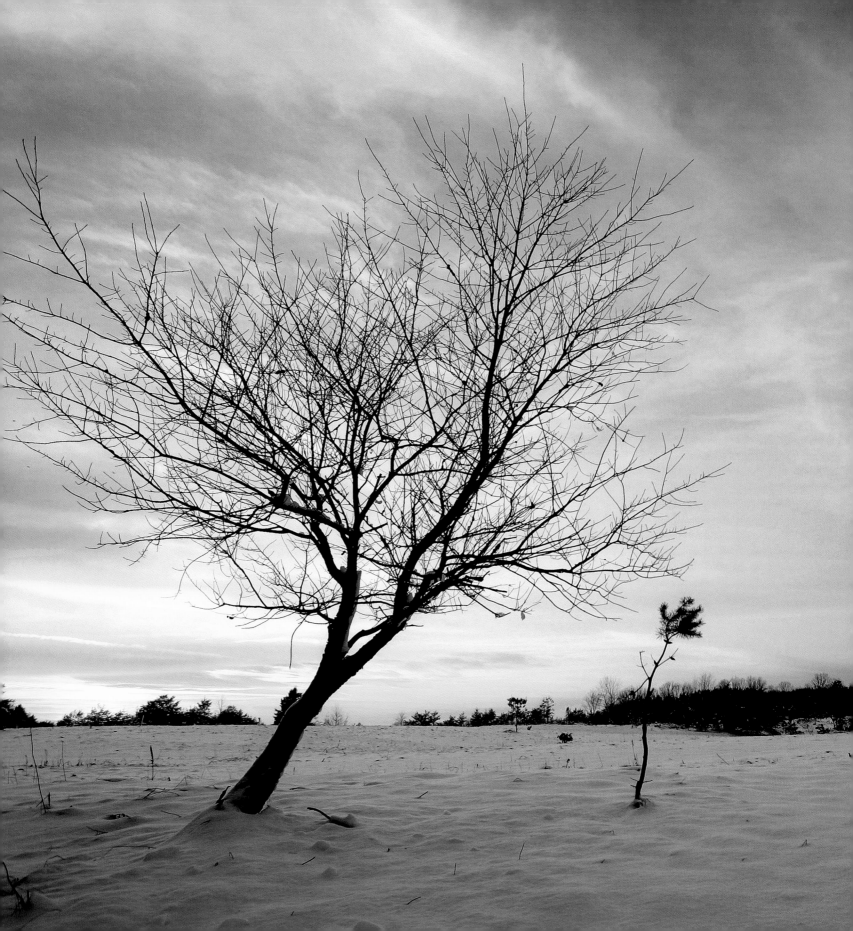

January 4, 2014

The sky is clear and the temperature hangs around zero when I wake up on this early January morning. There is no sound as I walk from the cabin to the woodshed for another load of firewood for the ever-hungry stove that heats my meals, warms the cabin, and brings back many memories of an earlier day on the home farm.

My regular routine each morning is to remove the ashtray from the stove and wallow through the snow to where I will plant my garden next spring. I dump the previous day's ashes where I plan to plant potatoes, for wood ashes are rich in potash, an element that potatoes need to grow well.

With the ashtray tucked back in the stove, I crumple up some newspapers, slip in a couple pieces of kindling, touch a match to the newspaper, and wait for the fire to start and the stove to begin warming the place. I open the oven door a little to let more of the heat escape into the room. By the time my breakfast is finished, the woodstove has increased the temperature in the cabin by several degrees. The teakettle on the stove is beginning to steam, and I am ready to begin work at the kitchen table. As I sit at my laptop, creating words and sentences, I think about the contradiction of being warmed by a woodstove that is as old as I am, perhaps even older, while I work at a modern-day device that no one had even conceived of when the woodstove was manufactured. My life is filled with these apparent contradictions. I don't see the past as colliding with the present. I see the past enhancing the present, adding depth and meaning to it, enriching the present rather than challenging it.

There is a practical side to working while being warmed by a woodstove. As a writer, I am often at loss for what to write next, how to construct the next sentence in a story, deciding on just the right word to make a point, and a host of other decisions that make writing the most challenging (also most fun) thing that I do. When I am stuck, I get up and put another stick of wood in the stove. It seems the stove always needs another stick of wood, and while I am feeding the stove, my subconscious is feeding me the next word, the next sentence, the next idea to explore—usually, but not always.

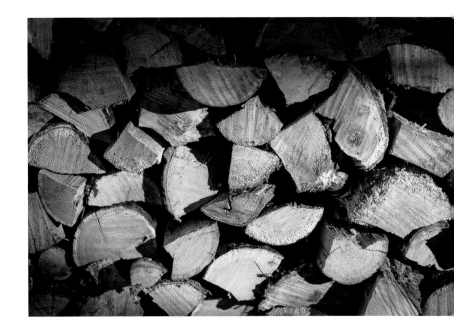

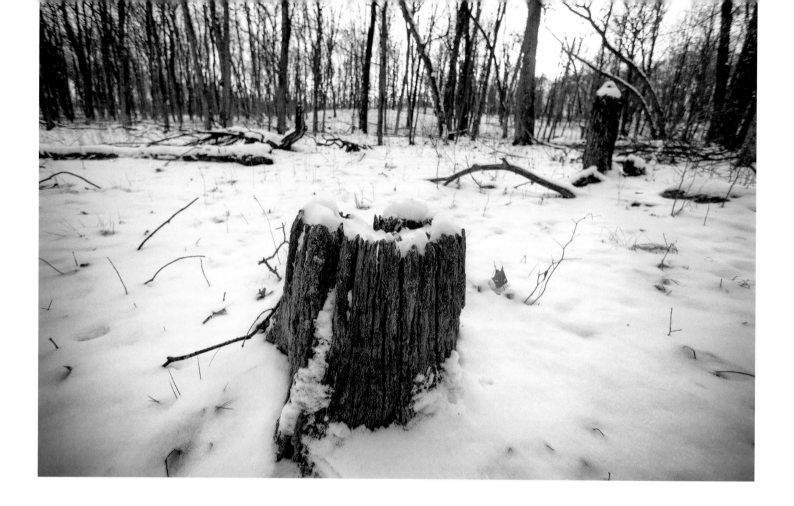

January 5, 2014

It is 16 below zero at Roshara, and by midafternoon the temperature has crawled to a balmy 12 above, but with a stiff southwest wind. A southwest wind is supposed to be warm, but not this one. I walked a half-mile or so and saw nothing but gray and white. Not even a crow, one of our toughest northern creatures. No deer—they know better than to wander around on a day like this. Only the creaking of the cold snow as I hiked, and the sound of the wind through the tops of bare oaks and pine trees.

I thought about the many days I walked to our country school on a day like this, with a cold wind blowing and no creatures about. Then I wore wool long underwear, wool socks, two pairs of bib overalls, a heavy wool shirt, a wool Mackinaw coat, a heavy wool cap with ear flaps, leather mittens with wool liners, four-buckle rubber boots—and to top it off, a woolen scarf that my grandmother Witt had knit and that my mother wrapped around and around my head until only my eyes were uncovered. If you fell wearing all those clothes, it was a challenge to get back up.

By the time I was halfway back to the cabin, walking into the wind, I remembered all of this, and I remembered especially fondly my wool scarf. I wished I had it today.

January 7, 1982

Ten below zero this morning. Wind chill minus 30. Fifteen inches of snow on the ground. It's winter.

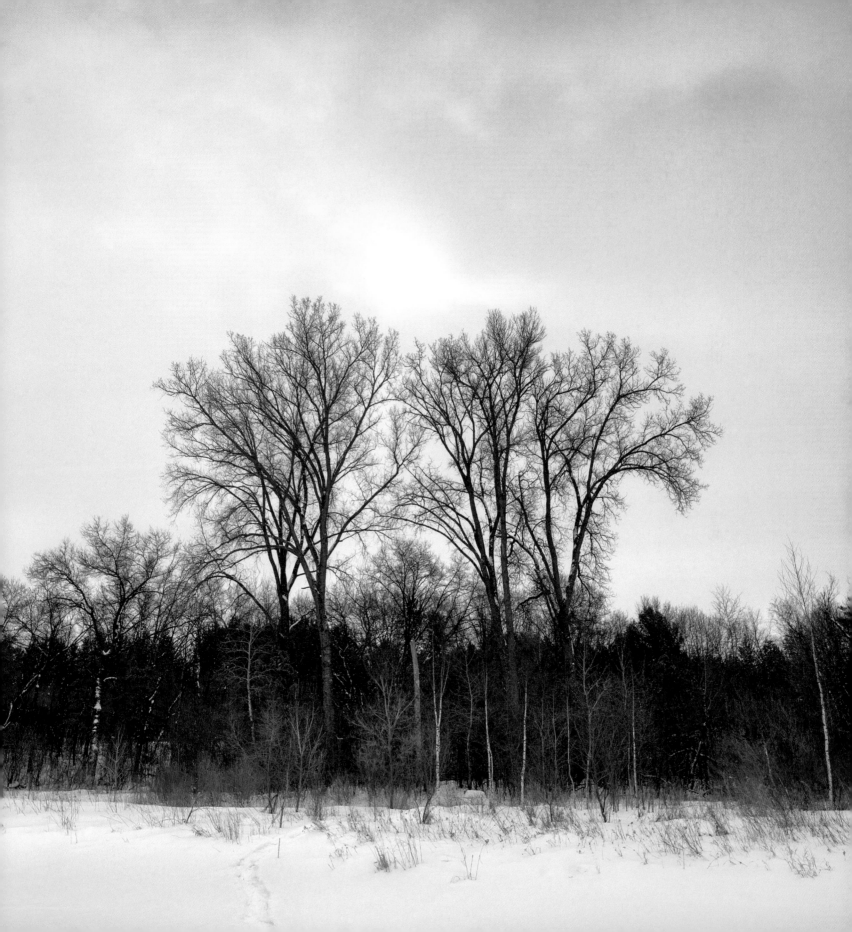

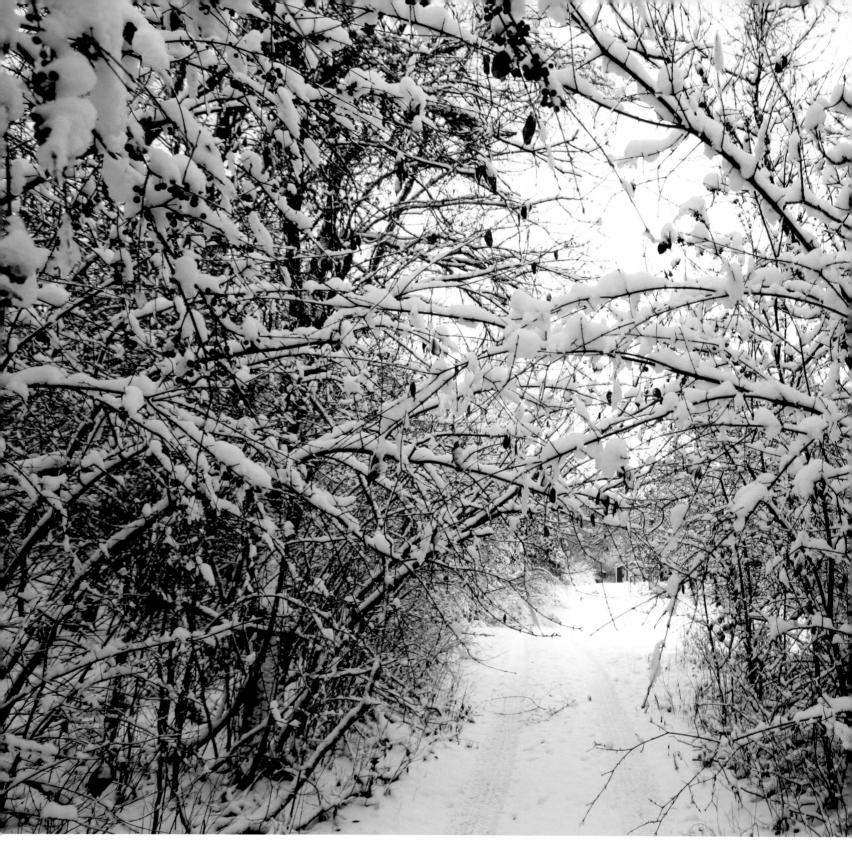

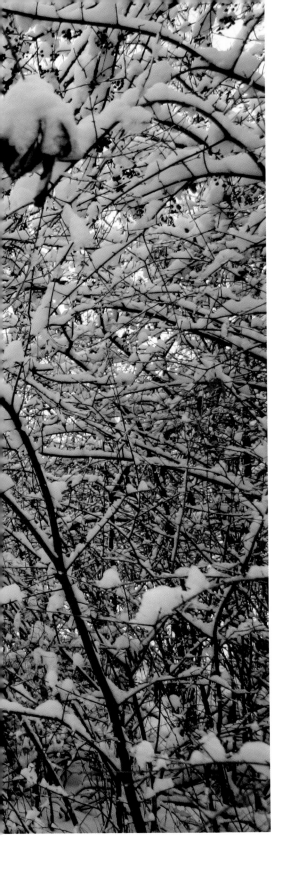

January 20, 2014

Cold weather snow. Light, fluffy, but persistent. The temperature hangs at 17 degrees and hasn't moved since sunrise. Small flakes. Not the big, puffy ones that fall when the temperature is warmer and the air holds more moisture.

Twelve to fourteen inches of snow cover Roshara, deeper where the wind has moved it. The driveway into the cabin is a narrow trail, piled high on each side by my tractor with its front-end loader. The snow falls steadily this morning as there is no wind. It accumulates on the bare branches of the black willows that protect the cabin from the wind. It gathers on the red pine near the driveway, causing the limbs to sag. It accumulates on the big spruce tree in front of the cabin and covers the woodpile stacked against the west side of the woodshed. It falls gently, slowly, and so quietly. Birds continue eating at the birdfeeder—nuthatches, chickadees, the occasional blue jay—all of them competing with the red squirrels that have packed a trail from the black willow trees to the source of an easy meal.

Besides the birds and the red squirrels at the bird feeder, there is no movement. No deer are moving. No turkeys. It's as if time has stopped and everything is waiting. Waiting for the snow to stop and the clouds to move on. Waiting for the temperature to rise a bit. But it's not going to happen. The weather forecast is for colder temperatures following the snow, below zero tonight with a wind chill of minus 25 and the winds predicted to pick up. And then more snow on Tuesday night and again on Wednesday.

These days are the depths of winter—what's expected here in the North. A reminder that as nature has slowed down, we might do so as well. There is a time to hurry and a time to slow down. A winter snowstorm reminds us of this rather simple but profound fact.

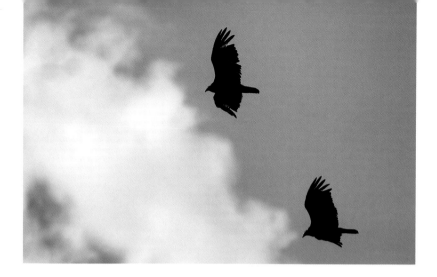

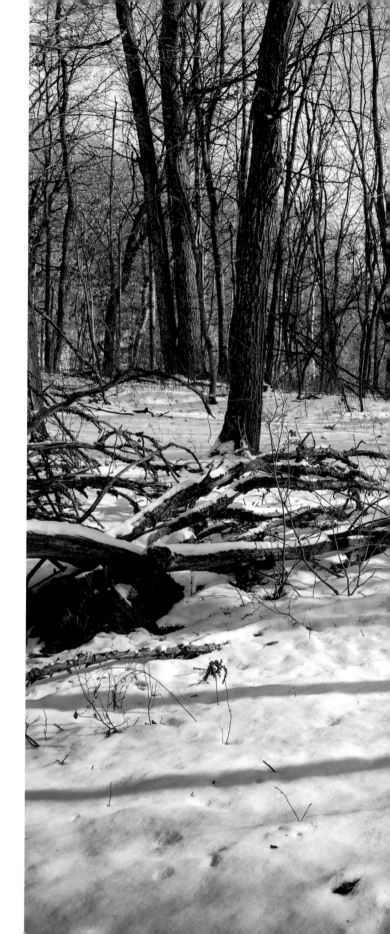

January 26, 1981

55 degrees on Saturday and low 50s on Sunday. Unheard of weather for January.

January 28, 1991

I was visiting with my ninety-one-year-old father this afternoon. He told me, "If I had to do it all over again, I would have spent more time fishing." He also said I should start doing it before it's too late. I think he has a point.

January 29, 2014

I look out the cabin window at first light and I see tracks. Tracks coming from the south, from the east, from the west through the break in the black willows that keep the winter winds at bay. And from the north, too, from the red pine plantation a couple hundred yards from the cabin. Tracks made by hungry deer, all converging on the bird feeder in the spruce tree that stands sentinel in front of the cabin.

Like spokes in a wheel, the tracks come together at the hub, those who left them hoping for some bird feed spilled by a messy blue jay or an even messier red squirrel. January 2014 has been a mean month for the winter critters, with many days below zero, a few dipping below minus 20. A challenging time for all of nature's creatures that winter in the North, searching for something to eat and a place out of the wind. And so they come, in search of leftovers at my bird feeder.

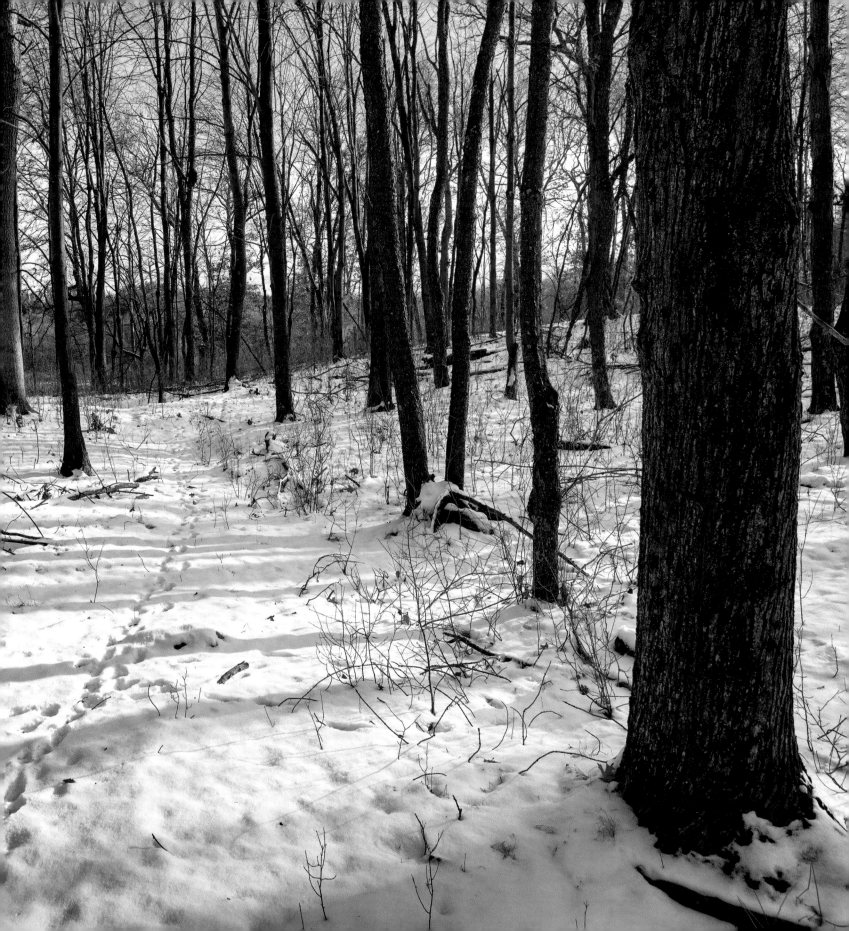

February 14, 1971

Valentine's Day. About thirty inches of snow on the ground, much more where it has drifted. Steve and I cross-country skied. Ideal conditions, but breaking trail takes some doing. Without my skis the snow is well above my knees, impossible for walking. Steve, who is only eight, skied along behind me. He did okay as long as he stayed in the track that I made.

While skiing we spotted a fox track and a few squirrel tracks in the woods, but there is little evidence of other wildlife. We did find a deeply worn deer trail in the woods—if the snow doesn't increase much more, they should do okay.

Ollie Hansel, my neighbor to the east, is feeding the deer corn and hay in a little opening in the woods that he reaches with his snowmobile. I also noticed that the deer were browsing heavily on the dogwood, the young maple trees, and the small bur oaks.

I shoveled the snow off the porch roof; in places it was four feet deep, and I feared the roof would cave in with the next snowfall. I wired a board to the end of an old garden rake to do the job. Hard work. I cleared most of the roof before the board broke and the rake separated from its handle.

Steve pointed out to me that a cottontail rabbit must have taken shelter in my tractor shed. He spotted the tracks where it crawled under the door.

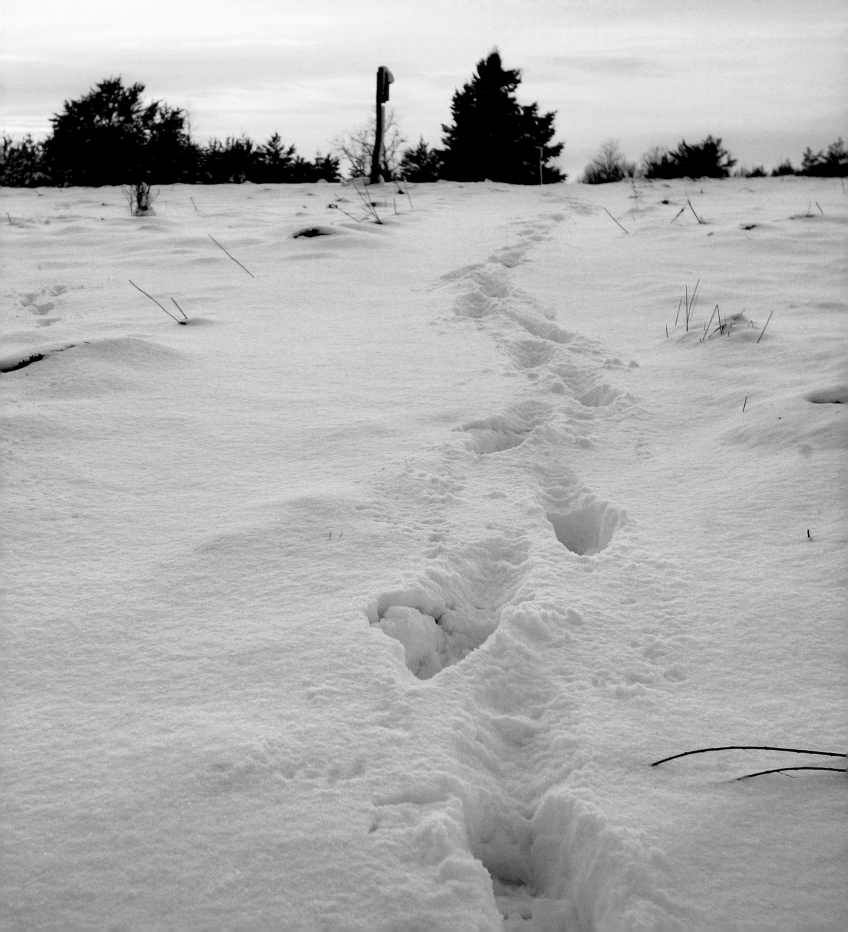

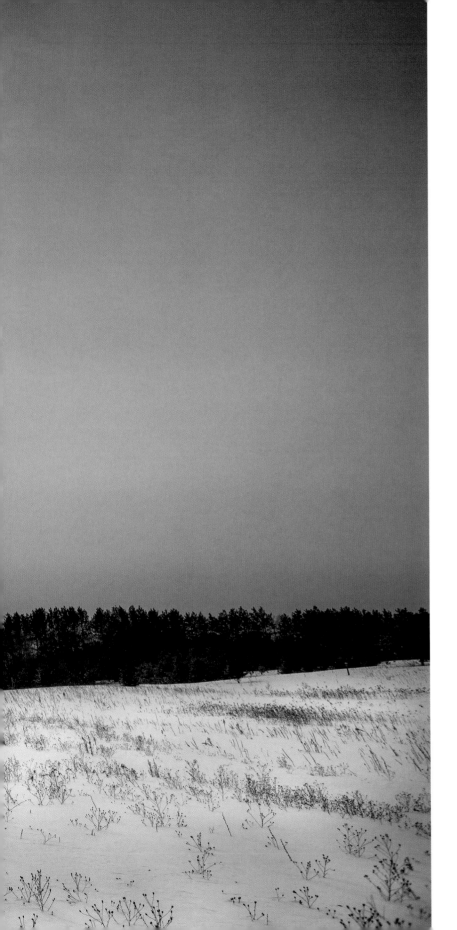

February 15, 2014
The sky is blue; the air is still; the snow is deep. The sun climbs slowly above the trees to the east—a huge yellow ball of warmth. But it is ten below zero and nothing is stirring, except for a large crow that flies overhead.

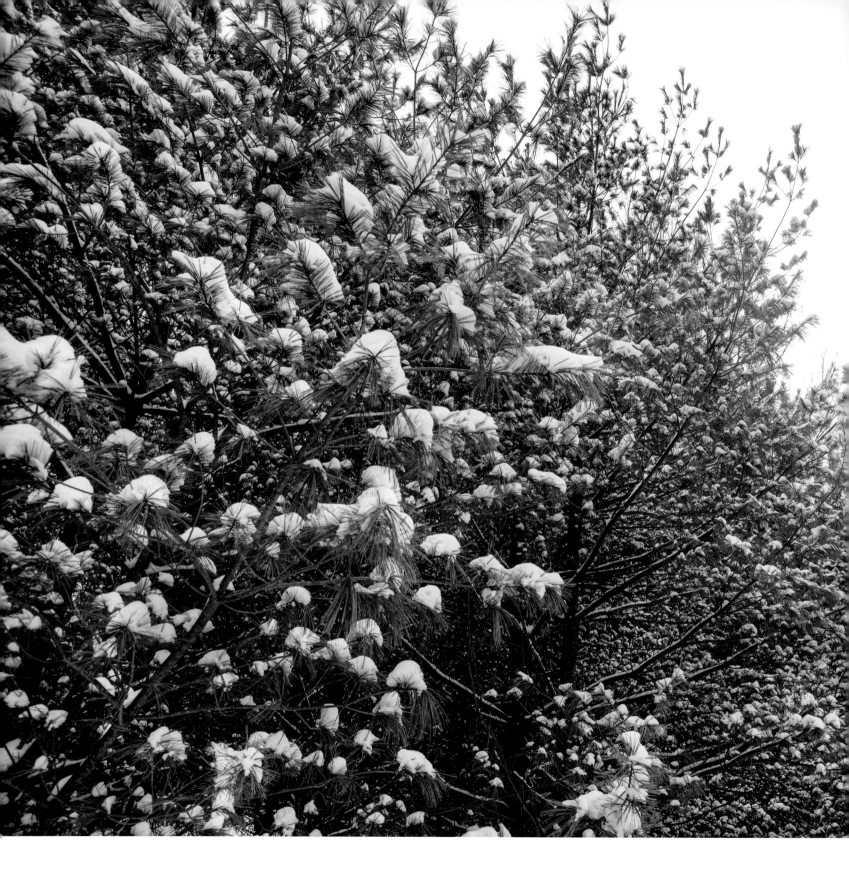

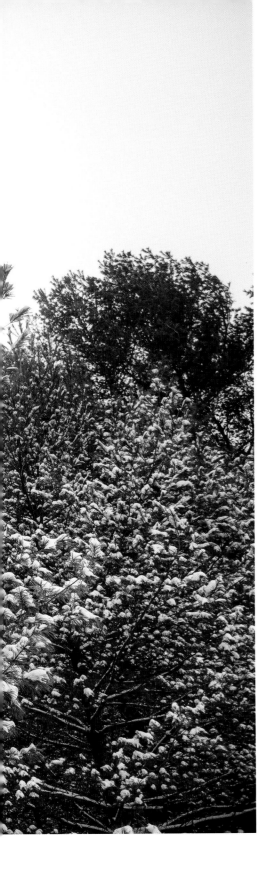

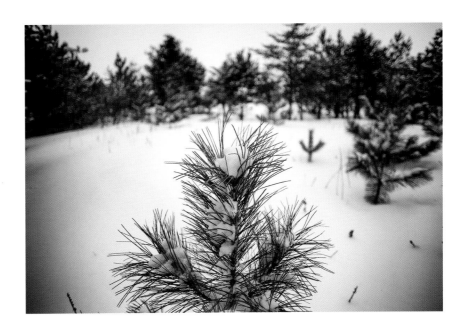

February 25, 1987

Beautiful weather continues; forties each day. I saw geese flying yesterday. Huge flocks strung out in lazy Vs, winging north and calling loudly. I suspect this is the flock that winters in southern Illinois, and with spring in the air they are getting a jump on the season.

March 1, 2014

Snow last night, a couple more inches. Snow again predicted for this evening. Snow up to the porch windows of the cabin. Snow halfway up the front door, which we don't use in winter. Winter weather. Not March weather. Spring, oh spring, are you hiding out there somewhere, waiting your turn, waiting your opportunity to send winter on its way for a few months?

Roshara is waiting. The deer and the wild turkeys, the sandhill cranes and the Canada geese, the robins and bluebirds—all waiting. The land waits, too. Buried with snow since November, well rested and ready to send forth new growth.

And I am waiting. As much as I enjoy winter, this time of year the thought of spring is on my mind as I gaze over Roshara's snow-covered fields.

About the Author and Photographer

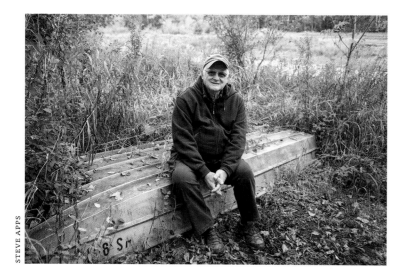

STEVE APPS

NATASHA KASSULKE

JERRY APPS is professor emeritus at the University of Wisconsin–Madison and the author of many fiction and nonfiction books on rural history, country life, and the environment. The topics of his books range from barns, one-room schools, cranberries, cucumbers, cheese factories, and the humor of mid-America to farming with horses, the Ringling Brothers Circus, and winter.

Jerry has created four hour-long documentaries with Wisconsin Public Television, among them *A Farm Story with Jerry Apps*, *A Farm Winter with Jerry Apps*, and *The Land with Jerry Apps*. He has won several awards for his writing and a regional Emmy Award for the TV program *A Farm Winter*.

Jerry and his wife, Ruth, have three children, seven grandchildren, and two great grandsons. They divide their time between their home in Madison and their farm, Roshara, in Waushara County.

• • •

Kate Thompson, senior editor at the Wisconsin Historical Society Press, has edited many of my books, and once more I am indebted to her for her work on this project.

I cannot thank my wife, Ruth, enough. She reads everything I write, be they newspaper columns, weekly blogs, or book drafts. If my writing doesn't pass muster with Ruth, it heads for the wastebasket.

And I must thank my three children, Sue, Steve, and Jeff—now grown, with their own families—who lived the adventures I describe in these journal entries.—JA

STEVE APPS lives in Madison and is the chief photographer for the *Wisconsin State Journal*. He has spent more than thirty years as a news photographer covering everything from sports to natural disasters. His photo coverage of the Green Bay Packers has been recognized five times by the Pro Football of Fame, and his photo of Brett Favre at Lambeau Field won the Dave Boss Award of Excellence and hangs in the Pro Football Hall of Fame. Other photojournalism honors include awards from the Pictures of the Year Competition, the Milwaukee Press Club, and the Wisconsin News Photographers Association. In 2012 the *Wisconsin State Journal* was a Pulitzer Prize finalist for Breaking News Reporting with an entry that included many of his photos. Steve also has contributed photos for many of his father's books, and he posts photos at his web page and several social media sites.

• • •

My mom and dad, Ruth and Jerry, have always been an inspiration and supportive. By raising three kids between Madison and, even more formatively, a sandy piece of property in Waushara County, they taught us to appreciate the wonders of nature and the changing seasons. And I thank my grandfather Herman Apps—gone now for several decades, but whose rural wisdom lives on in my father's writing and, I hope, in my photography.—SA